COUNTDOWN·TO·MILLENNIUM·

RODNEY MATTHEWS

Text by Nigel Suckling & Rodney Matthews

The Overlook Press
Woodstock · New York

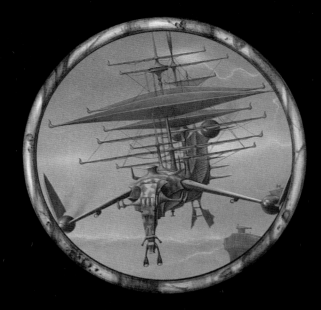

CONTENTS

First published in the United States in 1997 by
The Overlook Press, Peter Mayer Publishers, Inc.
Lewis Hollow Road
Woodstock, New York 12498

Library of Congress Cataloging-in-Publication Data
Matthews, Rodney
Countdown to millennium / Rodney Matthews ; text by Nigel Suckling
p. cm.
1. Matthews, Rodney, 1945- 2. Fantasy in art. 3. Sound recordings—Album covers.
4. Matthews, Rodney—Criticism and interpretation.
I. Matthews, Rodney. II. Title.
N6797.M333S83 1997 741.6′6′092—dc21 96-49517 CIP

Book design by Rodney Matthews

ISBN: 0-87951-780-9

Printed in Slovenia
First published by Collins & Brown Ltd, Great Britain

First American Edition
1 3 5 7 9 8 6 4 2

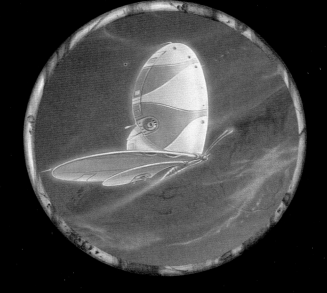

Rodney Matthews really needs no great introduction. He is internationally acclaimed as one of the foremost Fantasy artists at work today and the chances are that you already know his work well. Since the 1970s his unique visions and whimsical fantasies have been widely scattered over posters and record sleeves, in books and on book covers. He still remains busy in all these areas, but the 1990s have seen the birth of 'Multimedia Matthews'. Far from resting on his laurels, or anything else for that matter, he has actively been exploring new avenues, and his images these days are as likely to be found on a cathode ray tube as on printed paper.

You are also likely to have come across his previous anthologies *In Search of Forever* and *Last Ship Home*, or the CD-ROM *Between Earth and the End of Time*, which all consider his background and the influences on his art in some detail. So, not too much will be said about those here. The aim is to focus on what he has achieved, particularly in recent years.

New outlets for his imagination that Matthews has found include computer animation, computer game design and figurine design. On the music front he has produced a fresh wave of rather gothic album covers. This is thanks to his adoption as cover artist by a number of Christian thrash bands, who play a cacophonous brand of Heavy Metal rock music with apocalyptic lyrics that lend themselves particularly well to this style of illustration.

Other musical ventures include a joint musical-visual interpretation of the biblical Revelation with Rick Wakeman, and covers for the prestigious Asia albums *Aqua* and *Arena*. This volume also contains the first comprehensive catalogue of Rodney Matthews album covers, dating from 1969 to the present, together with pictures of the self-designed drum kit on which he takes out his frustrations when all else fails.

This book also covers the lighter side of Matthews' work with a series of rich and quirky illustrations for Lewis Carroll's 'Alice' tales, and a taste of his ongoing 'Nasties' and 'Lavender Castle' projects.

For those who do not already know, Rodney Matthews was born in 1945 in Somerset, where he grew up and mostly lived till 1985, when he moved to North Wales. There he shares a farmhouse on the edge of Snowdonia with his wife Karin (also an artist), son Yendor and daughter Elin Molly; plus a collection of border collies mostly descended from his original dog Patch, who has appeared in several paintings. Matthews studied graphic art at the West of England College of Art, and served an apprenticeship in advertising before going freelance in the early 1970s.

Since music has played such a large part in his work, both directly and indirectly, we open with a section devoted to it, and in which the artist will address you himself.

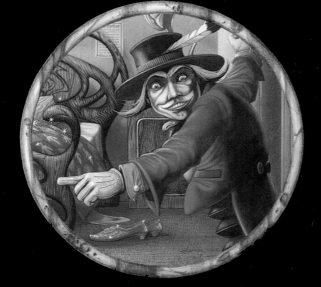

ƧΣᄃ丅I○ᄭ I : ᄭノᄂノƧIᄃ

Rodney Matthews: 'The appearance of the compact disc may have been a step forward for the reproduction standards of music, yet for the designer and illustrator of record covers it was a definite step backwards. The 12" LP with perhaps a gatefold became a miserable 12cm. I have adapted, but reluctantly.

'My first interest in record cover design goes back to the 1950s when I beheld the Bill Haley *Rock Around the Clock* EP. This cover, with its glossy laminated surface and gregarious design, seemed so far from the dull, brown paper envelopes used to package the 78 rpm. records of the previous generation. The bendable vinyl record with its large, full-colour sleeve had come to stay – for thirty years! And the bulk of my cover artwork was done within that golden age.

'I have often been asked to describe the process by which I arrive at a finished album cover. Early on, I had first to find the work by sending out 35mm slides and photocopies (never artwork) to prospective clients. I also rang record companies to arrange appointments to show my portfolio. The success rate, though not high, was just enough to keep up my perseverance.

'In the early 1970s I had a partnership business, Plastic Dog Graphics, specializing in design for the local music business in the Bristol area. Occasionally we would be asked to do a record cover on the strength of our posters, which was how the Thin Lizzy cover came about (page 40).

'In recent years I have been approached on the basis of my reputation or by word of mouth. Usually I am contacted by the band or its management rather than their record company. They normally send a demo cassette and perhaps a lyric sheet to establish the genre of music. In some cases, I have a completely free hand to make design suggestions but more often the band has some idea of what it wants – Magnum being a good example of this.

'Depending on the budget, my customer receives several well-defined pencil sketches (I keep the really rough stuff to myself). If one is chosen without alteration, I can use an enlarged version of the pencil drawing as the basis of the full colour illustration, done on my projector. Most of the work I do in this field is rendered in pigmented acrylic ink and drawn larger than the eventual print size. Artwork remains my own property and, although the customer usually views the finished artwork, an 8" x 10" transparency is provided for reproduction within the area of purchased rights – that is, record packaging in all formats, and all advertising and promotional requirements. I reserve the right to use the image in calendars, cards and anthologies like this. Occasionally the artwork is framed and sold at a gallery, but most I keep.

'In 1990 I became aware of a music genre that had previously escaped my attention – Christian rock and thrash! Dave Williams, the manager of Christian thrash band Seventh Angel, wrote to me after reading an article in *Kerrang!* magazine, asking about the possibility of providing cover art for their album *The Torment*. I then discovered that Dave and the band had had an indication (while praying about the cover and my involvement) that in my studio was a suitable piece of artwork. In fact I had some time before done poster art from The Revelation entitled 'The Five Months of Torment' (page 9), unpublished at the time, which subsequently turned out to be just what they wanted.'

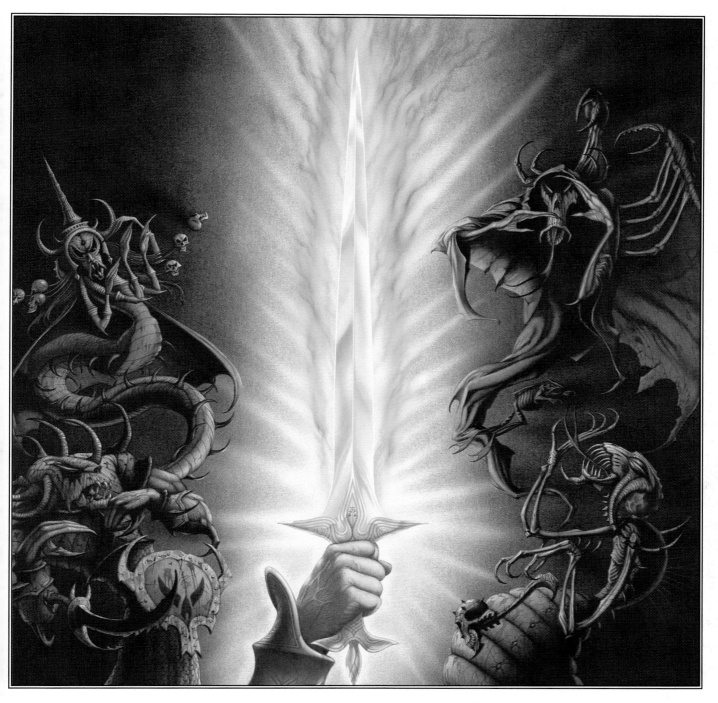

PERPETUAL DEFIANCE 1990
Inks. 40 x 40cm
Band: Detritus
Edge Records & Under One Flag

'My relationship with Dave Williams and Seventh Angel led to many other Christian rock album cover designs, including the one above. Detritus were a Bristol-based Christian thrash band just as loud and fast as any secular equivalent I have heard. The image is influenced by Ephesians 6:8. The pencil drawing on page 8 was for a proposed concept album based on Ray Bradbury's *Fahrenheit 451*, an anti-Utopian story of a future in which fire engines start fires rather than put them out! The project was eventually shelved.'

THE GAS DRAGON 1991
Pencil sketch

Page 9 FIVE MONTHS OF TORMENT 1990
(Based on Revelation 9) Inks. 70 x 100cm
Band: Seventh Angel
Edge Records & Under One Flag

'"Foundation" was produced at the request of Paul Birch for the cover of a Magnum boxed set, containing the albums *Kingdom of Madness*, *Magnum II* (with Matthews covers), *Chase the Dragon*, *The Eleventh Hour*, *On a Story Teller's Night* and *Mirador*. The idea was to include items from each album in the design: the stag from *Mirador*, the city from *Chase the Dragon*, my dog Patch from *On a Story Teller's Night*, and so on. The box also contained a poster and an illustrated booklet. The title *Foundation* was my own contribution, as was the man with the hat (Tony Clarkin ploughing his way through the difficulties of a life in rock!).'

FOUNDATION 1989
Inks. 50 x 100cm
Band: Magnum
FM Records

Inks. 48 x 63cm. Artiste: Rick Wakeman
Beckmann Video

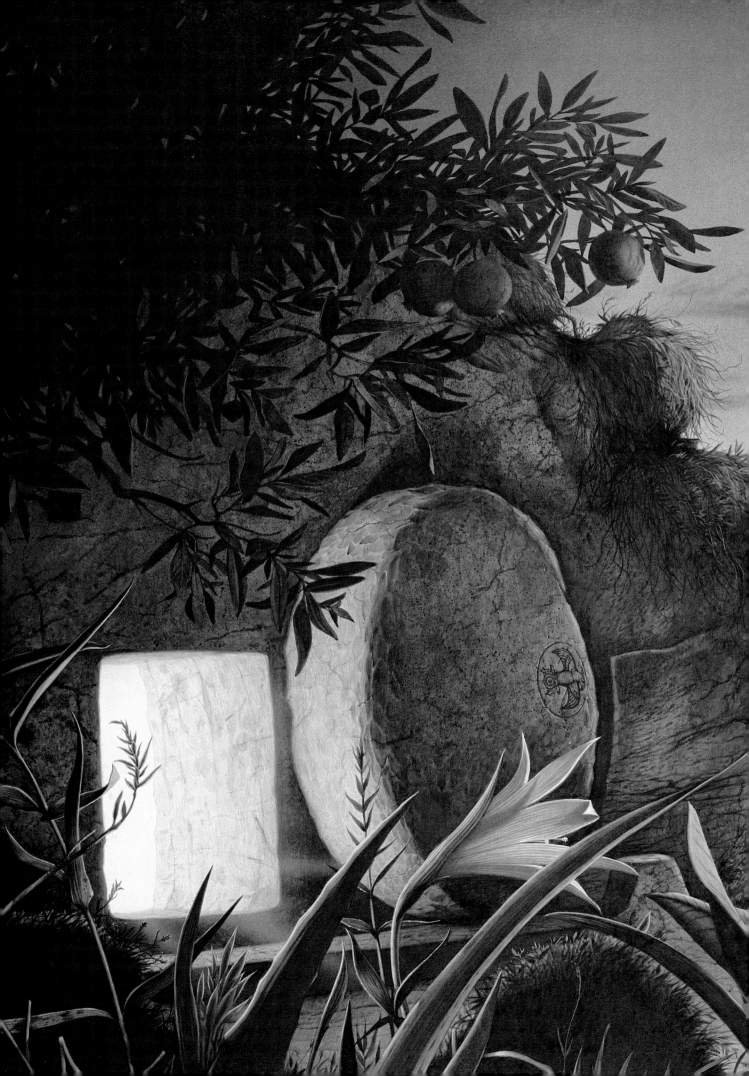

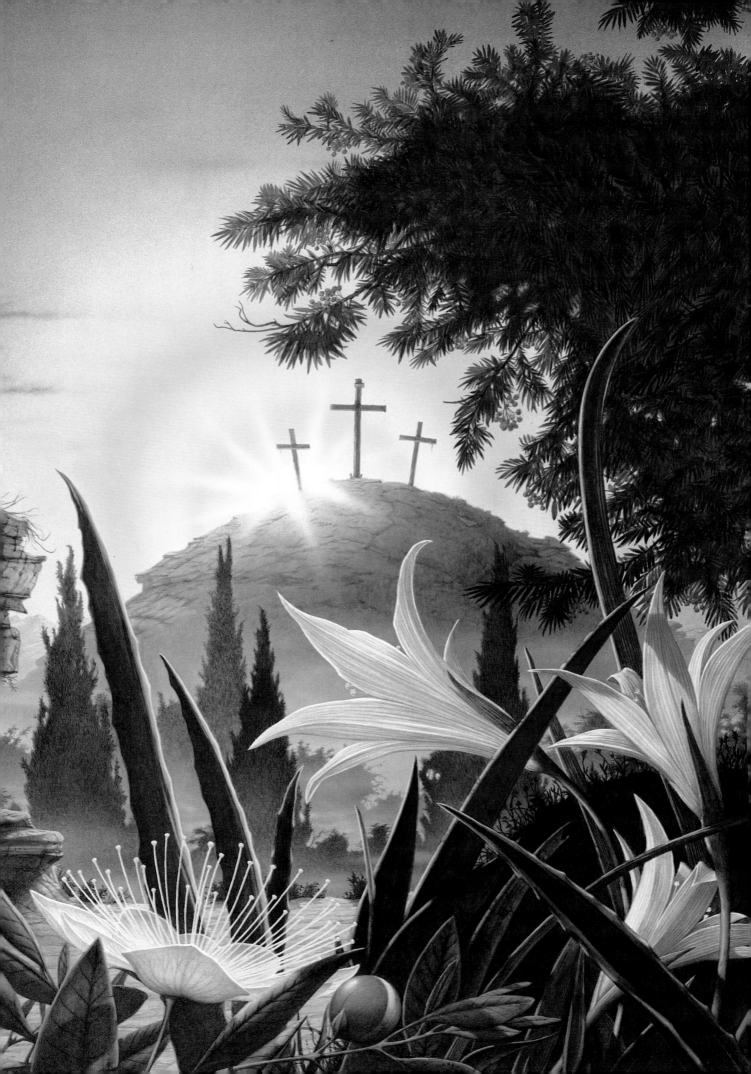

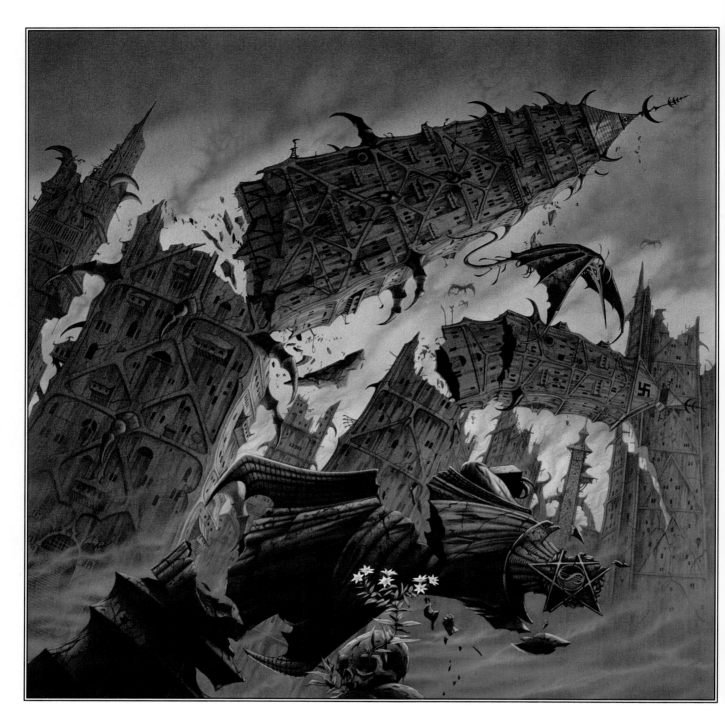

FALL BABYLON FALL 1991
Inks. 45 x 45cm
Band: Veni Domine
Edge Records

'"Son-Rise" on pages 12 & 13 was designed for use on a video box and CD cover. The illustration is based on Mark 16:6: "'Don't be alarmed,' he said, 'you are looking for Jesus the Nazarene, who was crucified. He has risen!'"

'The video was filmed at Rick Wakeman's open-air concert in the amphitheatre of Caesarea, Israel, where he was joined by Ramon Remedios, The Israel Symphony Orchestra and the Eton College Choir. Narration is by Robert Powell. Since this image, Rick and I have started other projects together, including that commencing page 88.'

FALL BABYLON FALL pencil sketch

'On the opposite page is my interpretation of the scripture from Revelation 18:2: "Fallen! Fallen is Babylon the Great! She has become a home for demons and a haunt for every evil spirit, a haunt for every unclean and detestable bird."

'This design was requested by the Swedish Christian metal band Veni Domine. The skull with white flowers is my own touch, symbolizing God's promise of bringing life out of death while the kingdoms of the earth rise and fall. The final design was selected from several pencil sketches, including the one above.'

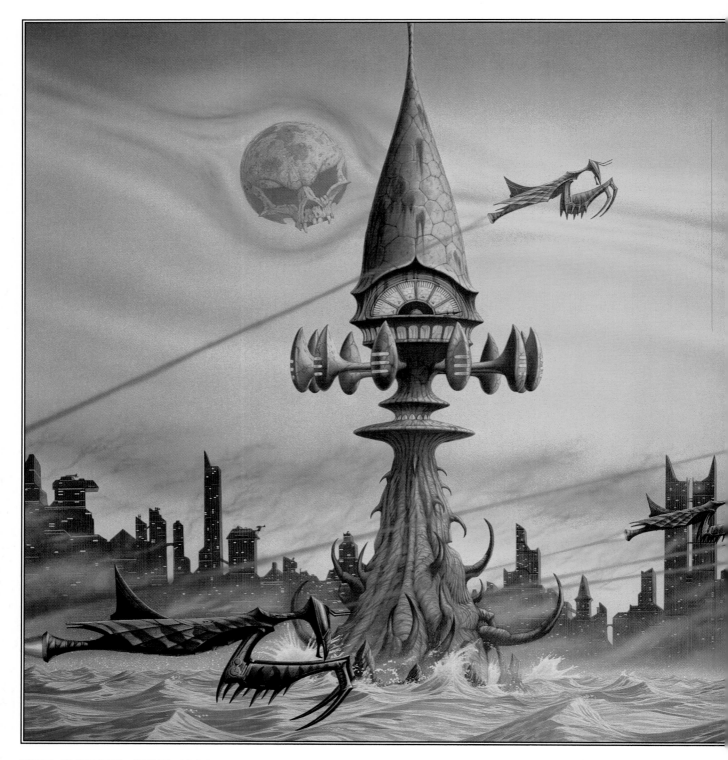

TIME SLIPPING AWAY 1991
Inks. 50 x 100cm
Band: Praying Mantis
Pony Canyon Records & Music for Nations

'Eleven years elapsed between my first album cover design for Praying Mantis (*Time Tells No Lies* page 47) and the one you see above for their album *Predator in Disguise* (page 53). Between the two albums the band seemed to disappear from public view. However, having taken part in a Japanese tenth anniversary celebration of the British "new wave" of heavy metal music, they were asked to record a new album for Pony Canyon, a Japanese record company.'

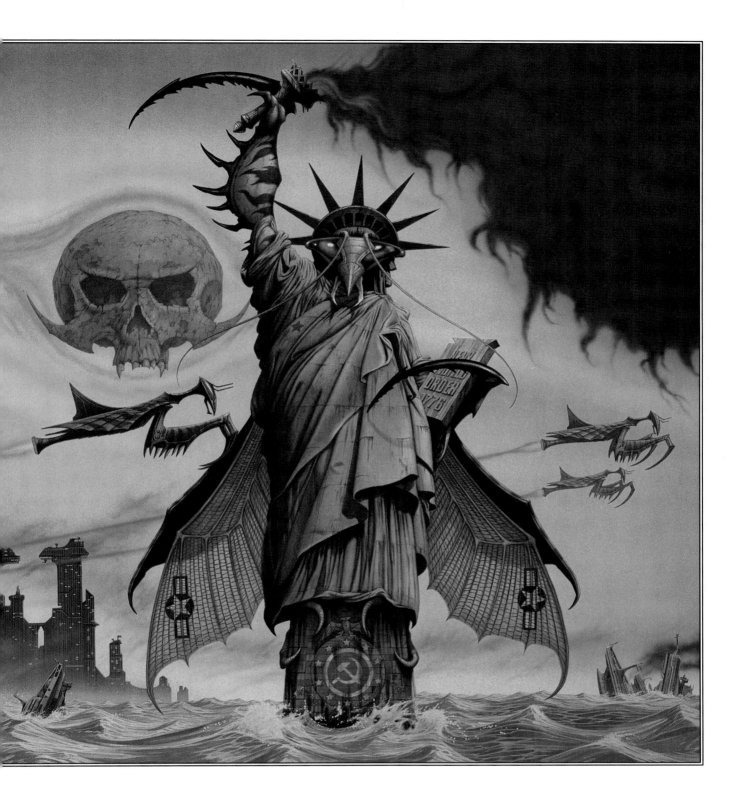

'Of course, as with *Time Tells No Lies*, there had to be a mantis in the picture, but the rest was up to me. I combined certain song titles and lyrics with my personal comments in the form of symbolism from Bible prophecies for the last days, such as the red sea and sinking ships (Revelation 8:8), the skull in the sky representing the darkened sun, and the skull on the left representing the moon turned to blood (Joel 2:31), and the universal government and monetary system (Revelation 13). It is my belief that this system, headed by the Illuminati founded in 1776, is currently represented on the US one dollar bill. As you will discover, if you read the Book of Revelation, this Luciferian system has sinister computations. Finally, the clock tower represents the six "days" of man's allotted time on earth. The needle is in a well advanced position.'

LAMENT FOR THE WEARY 1991
Inks. 41 x 41cm
Band: Seventh Angel
Edge Records & Under One Flag

'The second album design for Seventh Angel seen above, depicts a gloomy scene, but with a ray of hope! It is really saying: "Here is a man who has fought hard but has finally exhausted all possibilities." With all strength gone, he humbly awaits the intervention of the divine. This is from the following Bible verse: "Come to me all you who are weary and burdened, and I will give you rest," (the words of Jesus from Matthew 11:28).

'As a Christian I am aware that certain other Christians doubt the validity of this type of image, but my conscience is clear on this. My desire is to make a relevant presentation of the Gospels to a searching generation of young people.'

18

AQUA pencil sketches

'Harry Cowell, the former manager of Asia, approached me requesting suggestions for an album which at that time had no title. In the Asia tradition this title had to have an "A" at each end of a single word, so I rummaged through a dictionary and came up with the word *Aqua*. This suited their requirements well, as one of the tracks was being used in a film which in part advocated preserving the environment and the Earth's waterways. The band's founder Geoff Downes had also requested a "spacey" feel to the image, so most of my subsequent seven drawings included these two elements.'

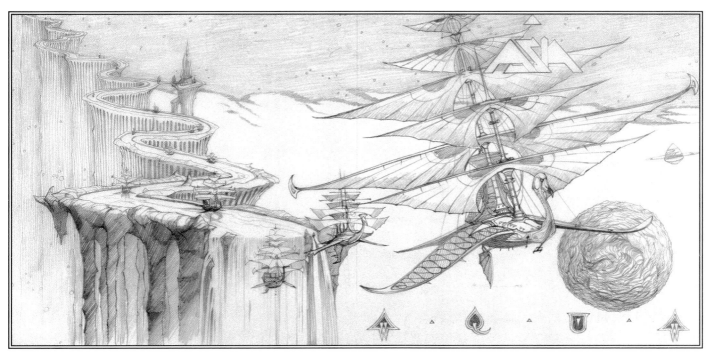

19

AQUA 1991
Inks. 50 x 100cm
Band: Asia
Musidisc, UK; Great Pyramid Records, US

'When the drawings were ready, Geoff Downes and John Payne visited my studio to decide on the appropriate image. Here I made the mistake of showing them the sketch I least liked myself, and of course this was the one they chose! The final version appears above, with the implication that God's creation remains while man's aspirations fall into ruin.'

AQUA alternative pencil drawing

'My own favourite of the bunch is this one, featuring a company of travellers resting from their toil and sampling some good clear water. The discerning eye will notice the reiteration of the record title in the mountains and river. The bird is derived from the European heron. Incidentally, the Asia logo is just visible in outline. This was designed by Roger Dean and is a logo I have long admired since seeing the original in his studio.'

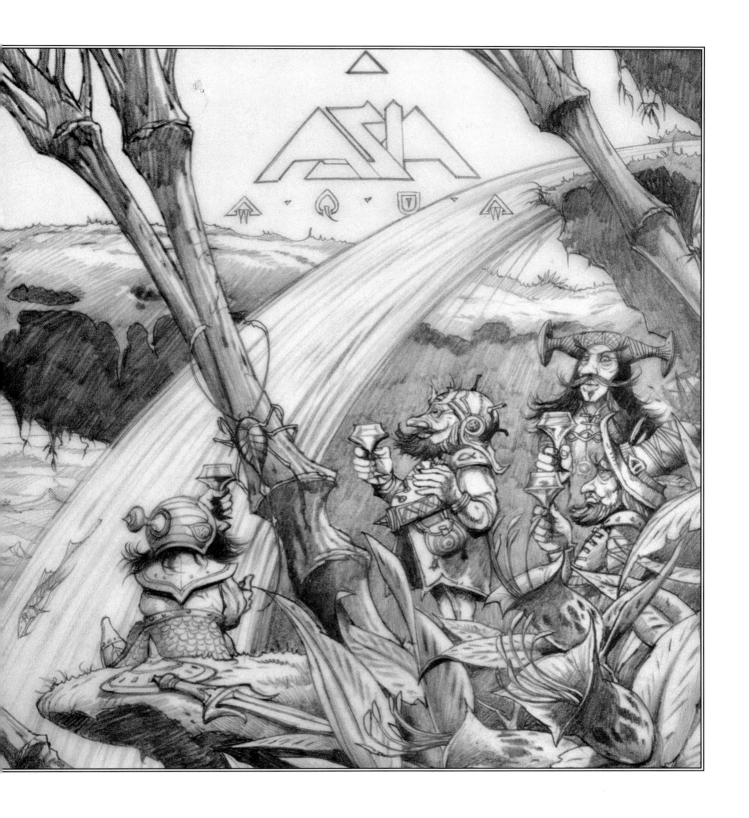

SLEEPWALKING 1992
Inks. 50 x 100cm
Band: Magnum
Music for Nations

'In true Magnum tradition, Tony Clarkin sketched out the essence of what he wanted for the *Sleepwalking* album, and in true Matthews tradition I made a few additions. The mirror shows Tony shaven-headed as he is now, beside a wig to remind people of how he used to look. The suggestion that he ever did wear a wig is purely my own little joke. Other of my inclusions are the jets from *The Eleventh Hour*, the bag and stick from *On a Storyteller's Night*, certain book titles, the Lord's Prayer scroll, Birmingham City football socks and the nose-boil ointment as used by Bob Catley when we discussed the cover (sorry Bob).'

'I seem to remember this illustration taking me twenty-six days and, while this is not typical of my style of illustration, it was a challenge I enjoyed. Also enjoyable were the several trips made to the Magnum studio where I was able to hear some of the tracks being laid down. This and the *Aqua* album were among the last of my designs to appear on the LP format.'

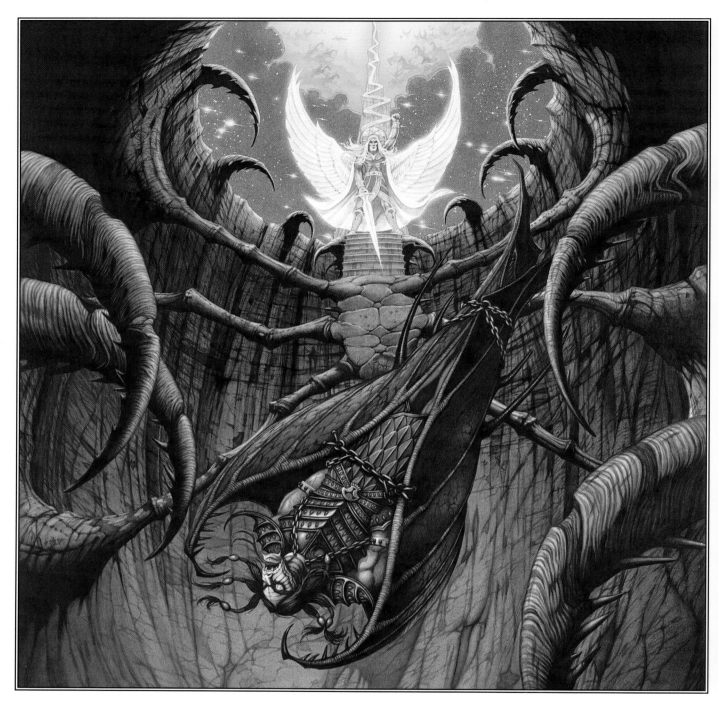

FALLEN FROM HEAVEN 1992
Inks. 41 x 41cm
Band: Stairway
Kingsway Music

'Though the title of this picture is "Fallen from Heaven", the album for which it was produced is entitled *No Rest, No Mercy* by the Christian rock band Stairway. It was influenced by the following scripture: "But you are brought down to the grave, to the depths of the pit," (Isaiah 14:15), a reference to the fall of Satan. Another interpretation of this event can be seen in the image "Into the Abyss" (page 95). Tracks on this album include "Battle of Heaven", "Meet the Maker" and "The Great Whore of Babylon".'

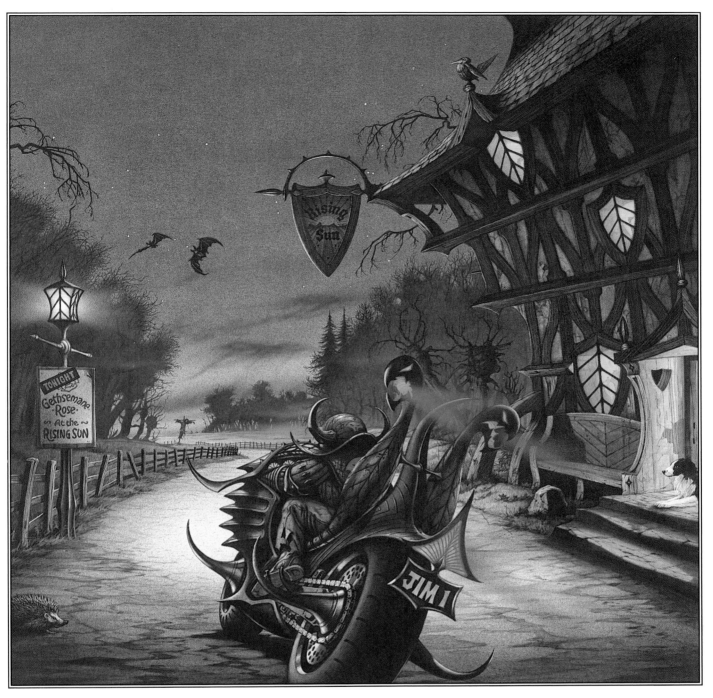

JIM'S LAST RIDE 1992
Inks. 41 x 41cm
Band: Gethsemane Rose
Kingsway Music

'The title of this picture was derived from the track "Jimmy's Luck" on the album *Tattered 'n' Torn*. Gethsemane Rose described the scene in detail, all I had to do was add some Matthews idiosyncrasies. The bike evolved from different machines in one of my son's motorcycle magazines. The dog is Patch again. In the song the rider dies in a crash before he has acknowledged his Creator. The scarecrow is symbolic of the Cross. Hence the scripture which accompanied this in my 1994 calendar: "Just as man is destined to die once, and after that to face judgement," (Hebrews 9:27).

'Much to my surprise I discovered that the band are the sons of people I used to meet with at a church at Welton, near Bristol.'

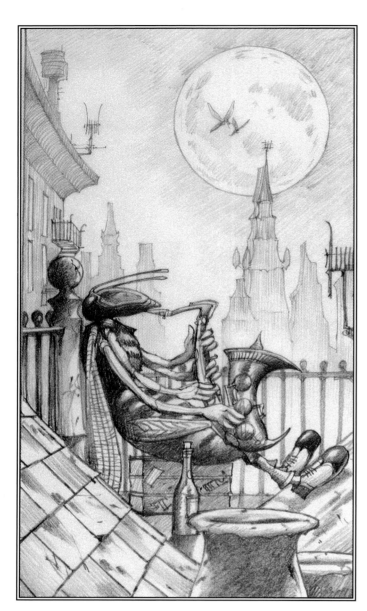

MILKY WAY BOOGIE 1993
Pencil sketch

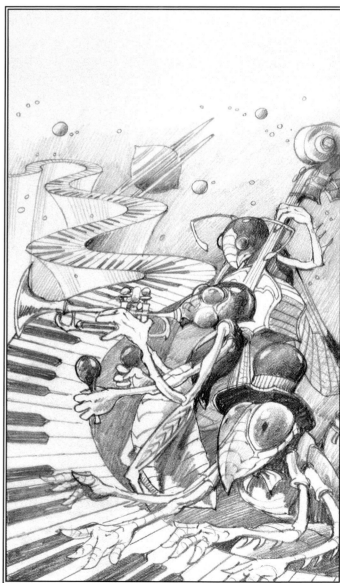

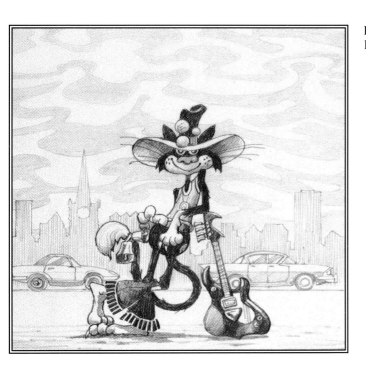

KOOL KAT 1993
Pencil sketch

'My recollections of how the sketches on these two pages came about are rather vague, though I remember they were done for Castle Communications. "Rooftop Serenade" and "Milky Way Boogie" were suggestions for a double CD and book for a jazz package. "Kool Kat" was for a 1960s style compilation and the "Guitar Ship" sketches were for a disco compilation. However, none of these designs met with the approval of Castle and, as they were aware of my style of design, I wondered why they asked me at all.'

GUITAR SHIP 1993 Pencil sketches

CAUGHT IN THE LIGHT 1993
Inks. 38 x 76cm
Band: Barclay James Harvest
Polydor Records

'I was pleased to be invited to participate in the cover design for this album because I can remember my band Squidd supporting Barclay James Harvest at a Bath University gig in the early 1970s. The design concept of this image belongs to Les Holroyd who explained how all their album covers have a butterfly included somewhere (see the Swallowtail, lower right).

 'As I was producing the first two rough sketches (page 32), my wife Karin who also trained as an illustrator, happened to be in my studio and remarked that she considered a lighter, rounder butterfly machine would be more appropriate for this

style of music. Karin did a sketch to illustrate her meaning and, with a few amendments, it was chosen by the band.

'It was my intention that the planet should appear above to create a feeling of vertigo. Unfortunately everyone's expectations are not always the same and the design has been printed upside down on two occasions! Several titles were proposed for this album, including *Silver Wings* and *Feel the Silence*.'

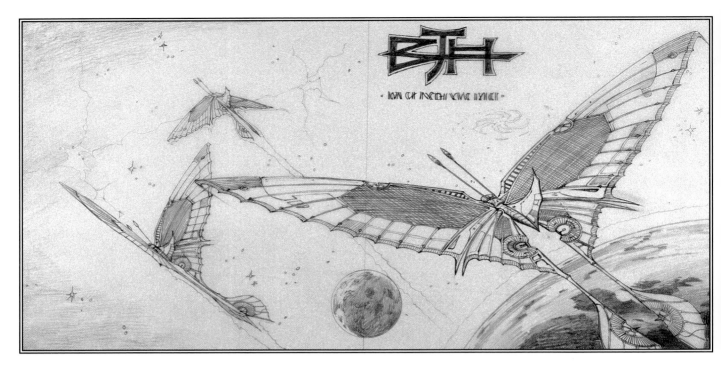

CAUGHT IN THE LIGHT Alternative sketches

'Karin also took a hand in the *Jurassic Church* album cover, in that she shot the photos used for the CD and publicity material, one example being shown on page 34. Rodd & Marco are Californian Christians living in Scotland. They have a comic-drama styled ministry that places Christian teaching into a storytelling mode, often mixing allegory with mainstream entertainment such as *Jurassic Park* and *Wayne's World*. My favourites on this album are "Radio Hell FM", "The Pied Piper" and "Jurassic Church", the latter being particularly agreeable to me because it exposes stagnation and the fossilizing of faith within the established church. It is part of my personal experience that prior to 1980, when I was desperately searching for truth and for the purpose of life, I occasionally looked in the direction of the so-called

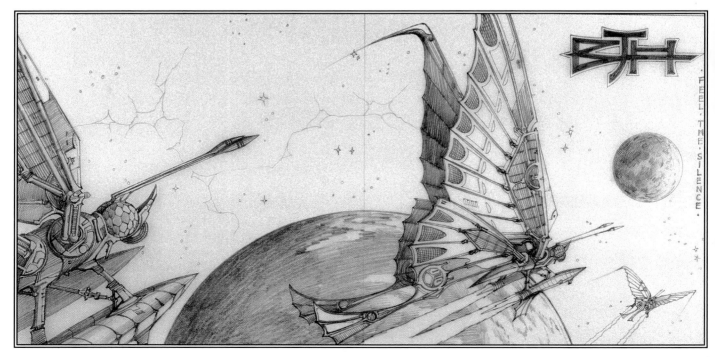

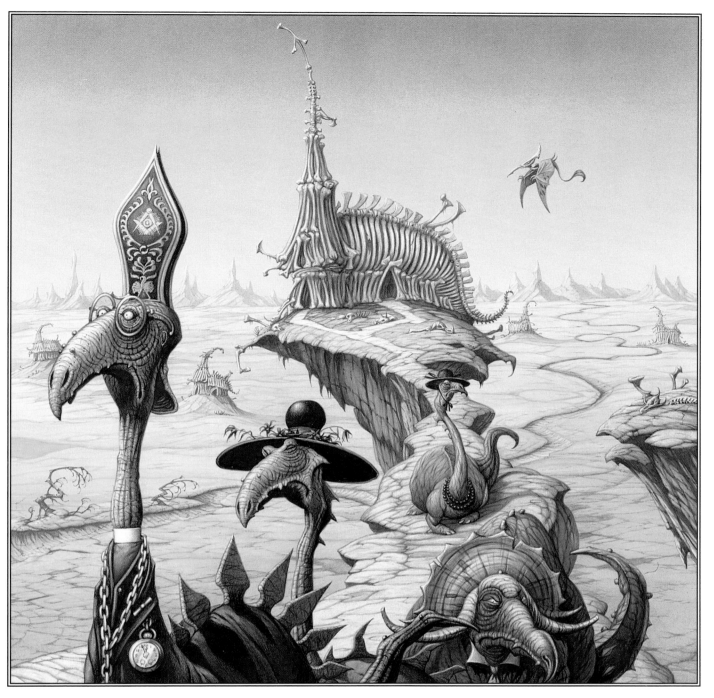

JURASSIC CHURCH 1994
Inks. 32 x 32cm
Artistes: Rodd & Marco
Kingsway Music

Christian Church and saw little else but dry bones. I thank God that since then, I have enjoyed the company of thousands of committed Christians who have a personal relationship with Jesus!

'Rodd & Marco included this Bible verse on the CD cover: "Then he said to me, 'Prophesy to these bones and say to them, "Dry bones, hear the word of the Lord!" This is what the Sovereign Lord says to these bones: "I will make breath enter you, and you will come to life…. Then you will know that I am the Lord." (Ezekiel 37:4–6).'

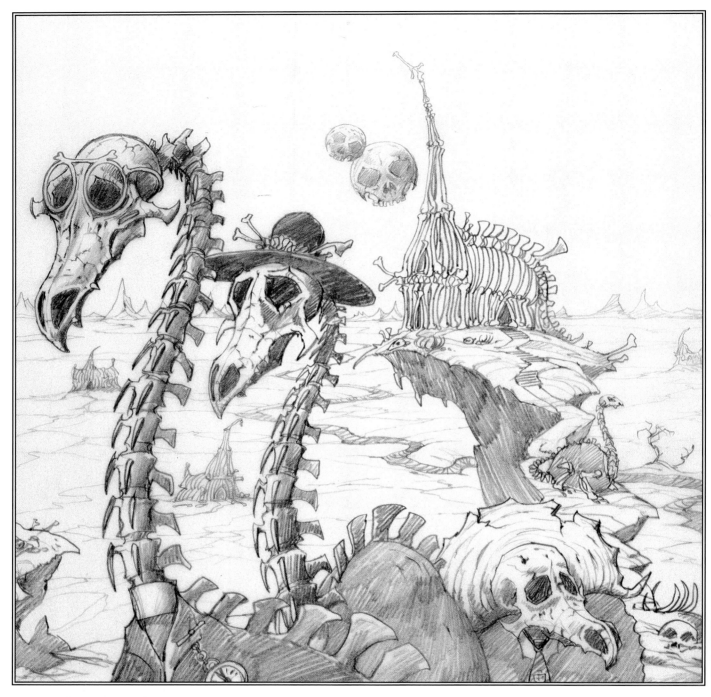

Alternative sketch for **JURASSIC CHURCH**

Rodd & Marco
Photograph by Karin Matthews

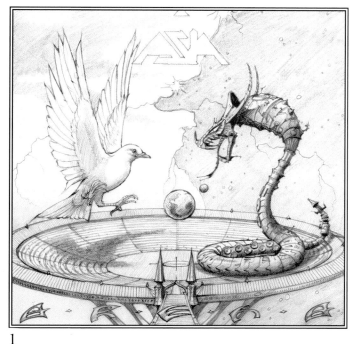

1

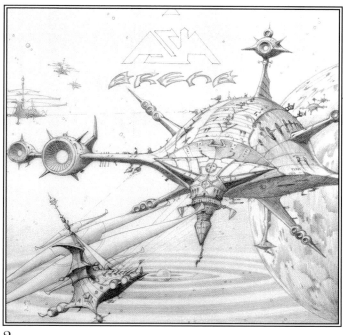

2

Alternative sketches for **ARENA**

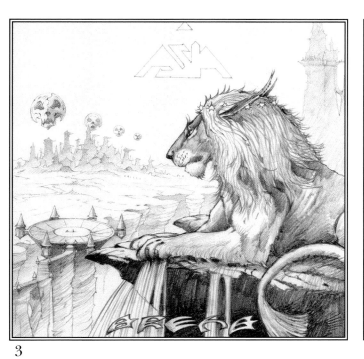

3

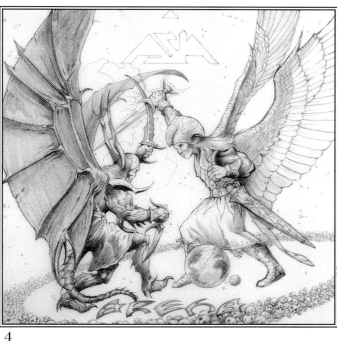

4

'Arena was my second Asia commission, but this time the title had already been decided and Geoff Downes was able to give me a fairly good idea of what was required – a confrontational scene of positive versus negative, or good versus evil. The pencil sketches above show my different approaches, each of which includes an arena of some kind: (1) the natural dove versus the mechanical and heartless cobra, (2) space galleons battling a formidable foe, (3) the mighty lion observing the affairs of men, and (4) a holy angel battles a fallen angel above the earth, with an orbiting ring of countless skulls of those fallen in battle.'

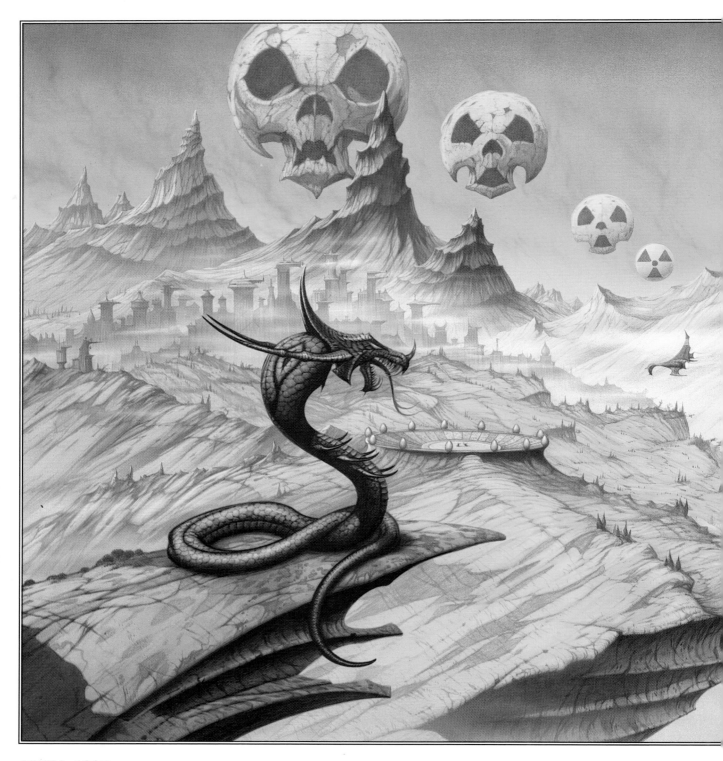

ARENA 1995
Inks. 50 x 100cm
Band: Asia
Intercord–EMI, Germany; Warner Music, Japan

'On comparing the sketches on page 35, I considered I had not quite hit the target, so I did a further drawing for the album front and reverse, derived from sketch (3). This was the one chosen by Geoff Downes and John Payne. The layout allowed me to make more of the nuclear symbol and its transformation into a skull. Ever since the Chernobyl disaster with its discharge of radioactive clouds over North Wales, I have become even more concerned about the tightrope we walk when using nuclear energy. Incidentally, the nuclear transformation image had been gathering dust in my "ideas file" for many years.'

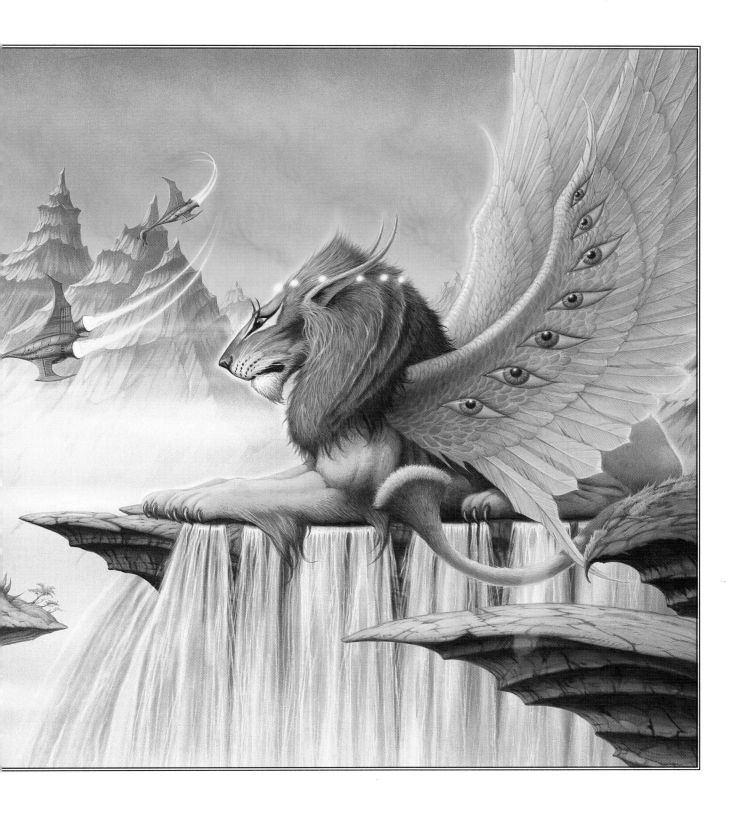

'The winged lion is something of a cross between Aslan, the great lion representing Christ from C. S. Lewis' "Chronicles of Narnia", and the six-winged lion before the throne of God in Revelation 4, the eyes under the wings seeing into the four corners of the earth. The cobra threatens while the lion bides his time! The aircraft were included to set the scene in the present or near-future.

'A note on technique: like most of my mainstream Fantasy work, this was painted with pigmented acrylic inks using airbrush for sky, mist and waterfall. The rest was painted with a No. 3 sable brush, starting from the distance and working towards the foreground.'

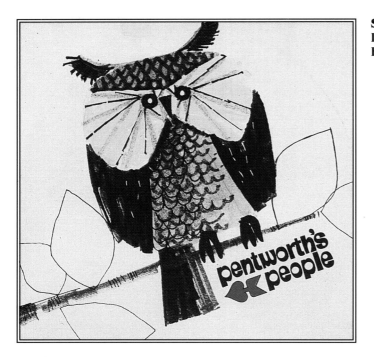

Seven inch demo. record cover 1965
Indian ink. 18 x 18cm
Band: Pentworth's People

Rejected record cover design 1974
Band: Magna Carta

'In the event that I have not been substantially represented in the well-known series of "Album Cover Albums", I decided to include a section on the history of Matthews record cover designs in this book.

'The demo cover for Pentworth's People above, used a line and wash technique in Indian ink. Pentworth's People was the third band I played in, following The Cheetahs and The Rhythm Cats (we wanted to change the name but keep the group van which was painted yellow with black spots!). Pentworth's People came about in the days of Op Art, Bridget Riley, Warhol and The Who. The band's stage visuals and dress became an important part of the show. I remember our stage clothes were made

Rejected record cover designs for
IT SEEMED A GOOD IDEA AT THE TIME 1974
Band: Stackridge

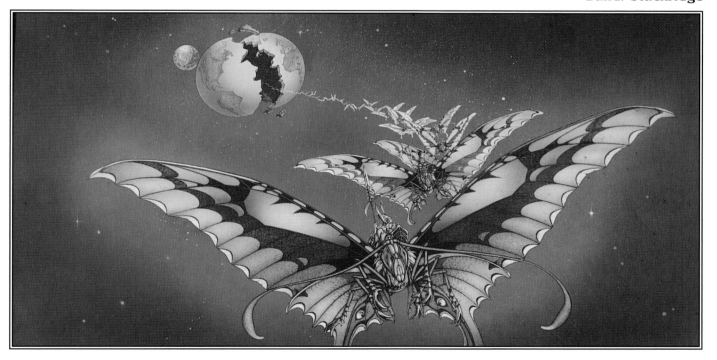

from very loud curtain material! Not many years before, while I was at art college in Bristol, the common room record player had churned out Thelonius Monk and Dave Brubeck on one hand, and the Shadows, Ventures and Eddie Cochrane on the other; but now we were all listening to the Beatles and Rolling Stones. By the time I had produced the Magna Carta image (which became *In Search of Forever*) and the various designs for Stackridge's *It Seemed a Good Idea at the Time* album (above), my rock days were almost over. I called it a day in 1974 to concentrate on my art.'

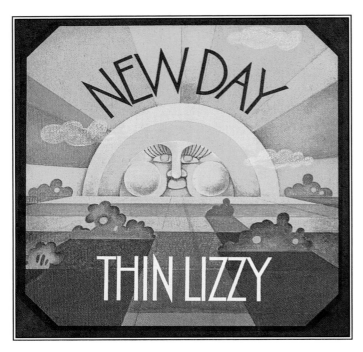

NEW DAY (EP) 1969
Thin Lizzy
Decca Records

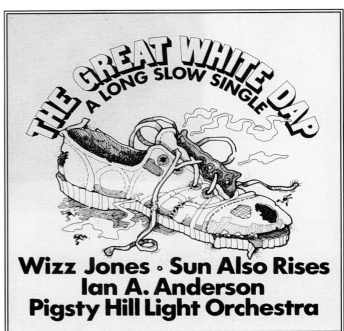

THE GREAT WHITE DAP 1971
Various Artists
Village Thing Records

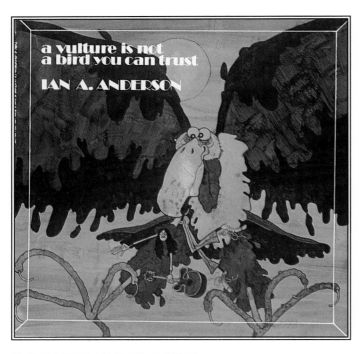

**A VULTURE IS NOT A BIRD
YOU CAN TRUST** 1971
Ian A. Anderson. Village Thing Records

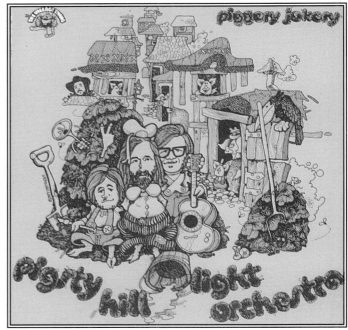

PIGGERY JOKERY 1971
Pigsty Hill Light Orchestra
Village Thing Records

'The Thin Lizzy EP cover above was painted with acrylic gouache on canvas as a freelance commission in my final year at Ford's Advertising, Bristol. *The Great White Dap* was a simple Indian ink and Letraset job. Ian A. Anderson's *A Vulture is not a Bird You Can Trust* (he favoured long-winded titles) was done as black and white artwork, using pen and soap-wash with two overlays for colour. *Piggery Jokery* was again done using a simple pen line technique.'

THIS IS HOW IT ALL BEGAN Vol. 2 1972
Various Artists
Specialty Records

MAGIC LANDSCAPE 1972
Hunt & Turner
Village Thing Records

ELEPHANTASIA 1972
Dave Evans
Village Thing Records

SINGER SLEEPS ON AS BLAZE RAGES 1972
Ian A. Anderson
Village Thing Records

'*This is How it All Began Vol. 2* was the second in a series on rock 'n' roll legends, including Little Richard, Lloyd Price and Sam Cooke. The other covers for the series have been lost. Another line and soap job, *Magic Landscape,* also included some Matthews drumming on several tracks whilst Dave Evans' *Elephantasia* suffered from some Matthews conga and clave playing! The Anderson cover was a pencil drawing printed in one colour. His flat really did catch fire while he slumbered (the title is from a newspaper report).'

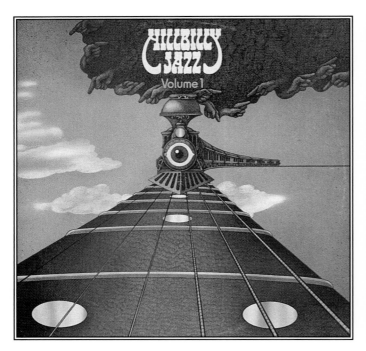

HILLBILLY JAZZ Vol. 1 1972
Various Artists
Sonet Records

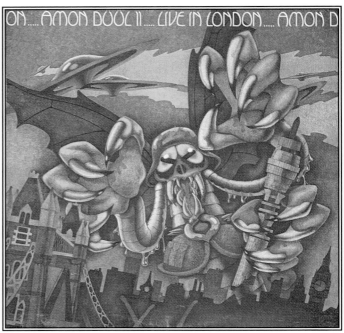

LIVE IN LONDON 1972
Amon Düül II
United Artists Records

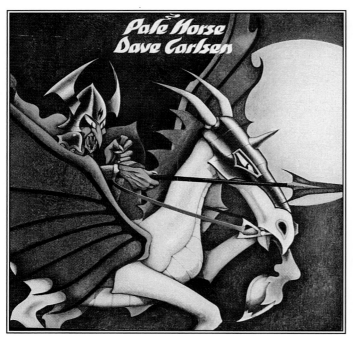

PALE HORSE 1973
Dave Carlsen
Spark Records

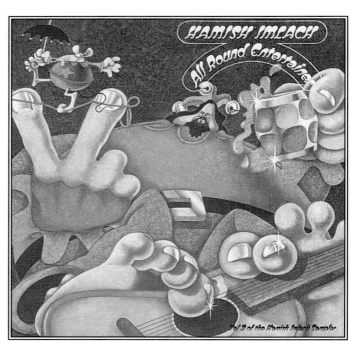

ALL ROUND ENTERTAINER 1973
Hamish Imlach
Transatlantic Records

'*Hillbilly Jazz Vol. 1* was my first airbrush illustration. "What happened to Volume 2?" I hear you ask. They cheated by using a blow-up of the central part of the Volume 1 picture! Returning to acrylic gouache on canvas for the other three covers above, I enjoyed the injection of humour in the Hamish Imlach picture. What I didn't know with *Pale Horse* was that the title was based on the last of the four horsemen from the Book of Revelation. The record had input from Noel Redding, Keith Moon and Spencer Davis.'

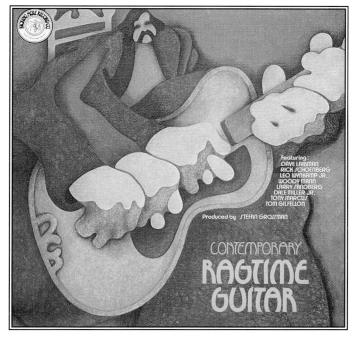

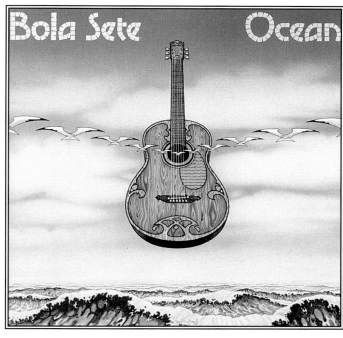

CONTEMPORARY RAGTIME GUITAR 1973
Various Artists
Kicking Mule Records

OCEAN 1973
Bola Sete
Sonet Records

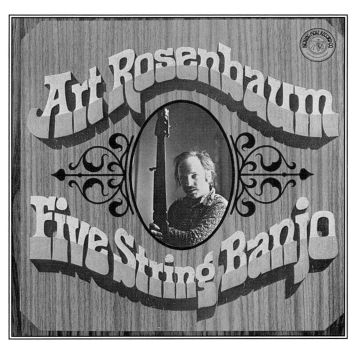

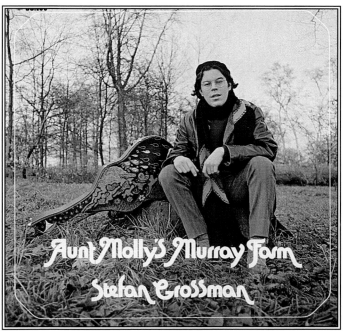

FIVE STRING BANJO 1973
Art Rosenbaum
Kicking Mule Records

AUNT MOLLY'S MURRAY FARM 1973
Stefan Grossman
Sonet Records

'Even though these four covers were all produced in the same year, they employed completely different techniques: *Contemporary Ragtime Guitar*, acrylic gouache on canvas; *Ocean*, inks with brush and airbrush; *Five String Banjo*, designers' gouache on woodgrain paper with a sepia-toned photograph; and *Aunt Molly's Murray Farm*, colour photograph with hand-drawn lettering. I did a similar cover for Stefan Grossman titled *The Gramercy Park Sheik*.'

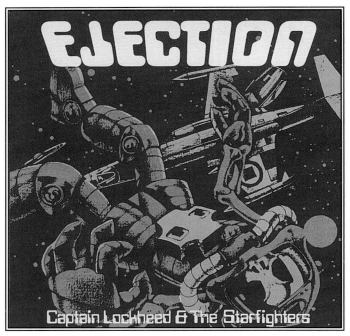

EJECTION (EP) 1973
Captain Lockheed & The Starfighters
United Artists Records

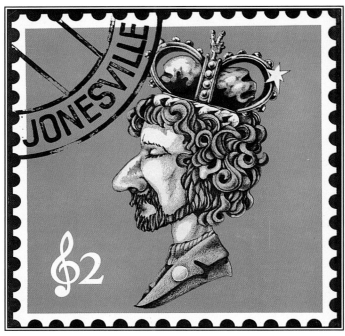

JONESVILLE 1973
Al Jones
Village Thing Records

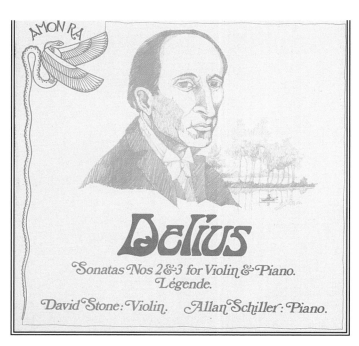

DELIUS 1973
David Stone & Allan Schiller
Amon Ra

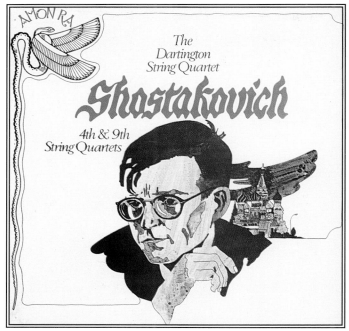

SHOSTAKOVICH 1973
The Dartington String Quartet
Amon Ra

'*Ejection*, *Jonesville* and *Delius* were all pencil drawings with overlays for colour, while the *Shostakovich* sleeve was done in line and soap-enriched Indian ink. Incidentally, *Ejection* featured Robert Calvert, Nik Turner, Paul Rudolph, "Lemmy", Del Dettmar, Simon King and Twink. They might as well have called themselves Hawkwind!'

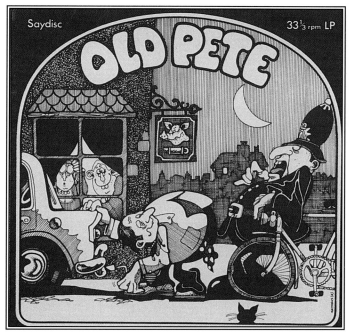

OLD PETE (6" LP) 1974
Old Pete
Saydisc Records

OLD PETE'S CHRISTMAS STORY (6" LP) 1974
Old Pete
Saydisc Records

GEOFFREY WOODRUFF 'LIVE' (6" LP) 1974
Geoffrey Woodruff
Saydisc Records

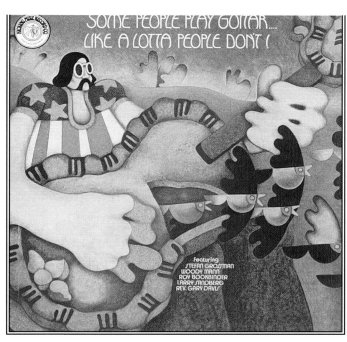

SOME PEOPLE PLAY GUITAR
LIKE A LOTTA PEOPLE DON'T! 1974
Various Artists. Kicking Mule Records

'If you happen to be a Bristolian you are likely to enjoy the absurd stories of Old Pete, told in a strong Bristol dialect. The first cover depicts a drunk trying to start his car at the wrong end, or so it seems. In fact he came out of a pub and, reversing into a pile of wet sand, stalled his engine. The policeman appears as he is removing sand from the exhaust with a revolving motion of his starting handle! (That dates it a bit.) *Some People Play...* is a companion piece to *Ragtime Guitar*, also acrylic gouache on canvas.'

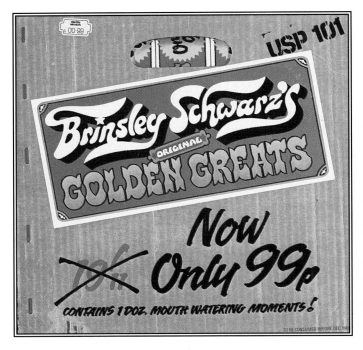

GOLDEN GREATS 1974
Brinsley Schwarz
United Artists Records

HALFBREED 1975
Halfbreed
United Artists Records

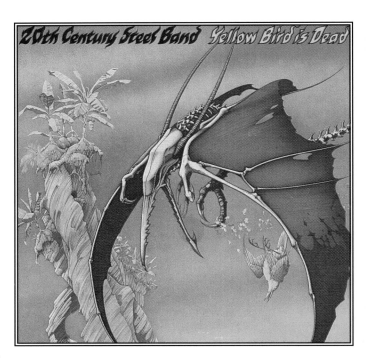

YELLOW BIRD IS DEAD 1976
20th Century Steel Band
United Artists Records

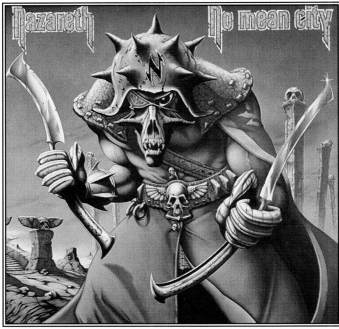

NO MEAN CITY 1978
Nazareth
Mountain Records

'With the exception of Thin Lizzy's *New Day*, all covers shown in this historic section up to *Yellow Bird is Dead* were done at the Plastic Dog Studios, Bristol. *Golden Greats* used gouache on a chunk of corrugated cardboard. *Halfbreed* was a gatefold in which the record lifted to show the record player and, on the reverse, its innards. The ink technique of *Yellow Bird is Dead* proved to be popular, and enjoyable for me, so I've largely stuck with it ever since. *No Mean City* was my first job working solo.'

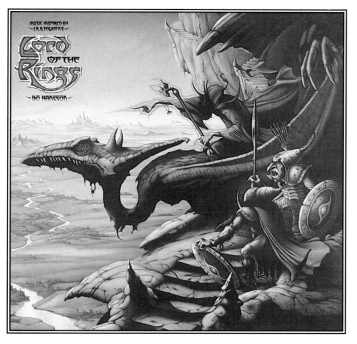

LORD OF THE RINGS 1979
Bo Hansson
Charisma Records

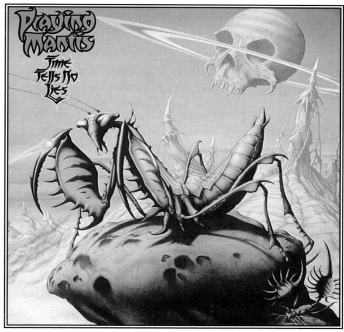

TIME TELLS NO LIES 1980
Praying Mantis
Arista Records

PRAYING MANTIS (Single) 1980
Praying Mantis
Gem Records

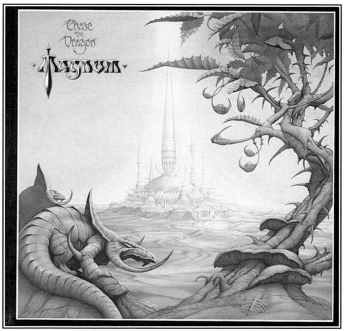

CHASE THE DRAGON 1980
Magnum
Jet Records

'There are at least ten more record covers I did at Plastic Dog with Terry Brace, but unfortunately at the time of print I have been unable to lay my hands on any samples. The current style of Matthews illustration really began to solidify around 1975. A good example is the *Lord of the Rings* repackaged album above. I had so much enjoyed reading the book that illustrating some of the scenes became a necessity for me.'

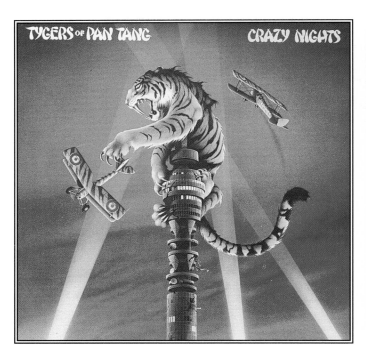

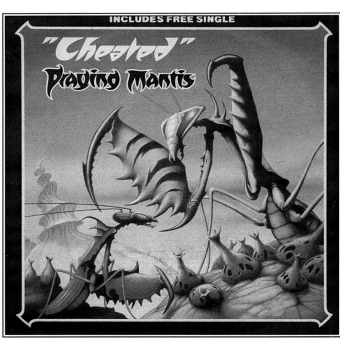

CRAZY NIGHTS 1981
Tygers of Pan-Tang
MCA Records

CHEATED (EP) 1981
Praying Mantis
Arista Records

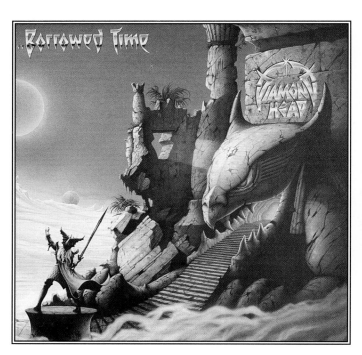

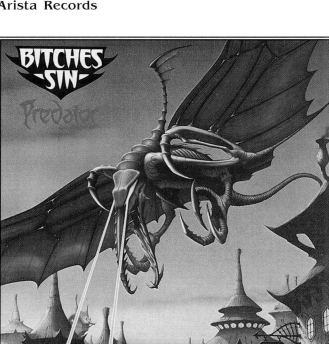

LIVING ON BORROWED TIME 1982
Diamond Head
MCA Records

PREDATOR 1982
Bitches Sin
Heavy Metal Records

'The four designs here were all done for bands emerging around 1980, who were collectively placed under the banner of "the new wave of British Heavy Metal". The *Predator* painting (not unlike the *Yellow Bird is Dead* creature) was the first of many commissions I received from Paul Birch and his labels Heavy Metal and FM records.'

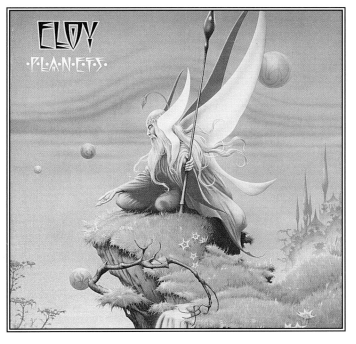

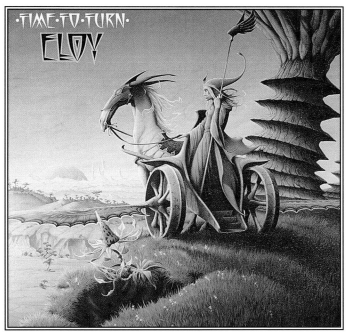

PLANETS 1982
Eloy
Heavy Metal Records

TIME TO TURN 1982
Eloy
Heavy Metal Records

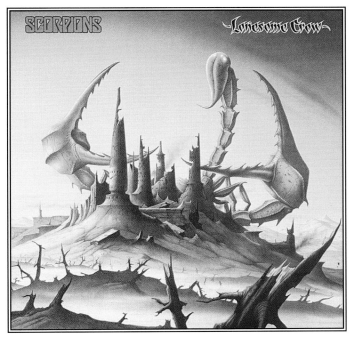

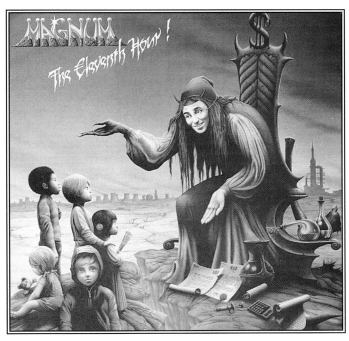

LONESOME CROW 1982
The Scorpions
Heavy Metal Records

THE ELEVENTH HOUR 1983
Magnum
Jet Records

'The full extent of these images can be seen in my first book of this kind, *In Search of Forever*. All except *Lonesome Crow* have been marketed as posters as well. Magnum's *The Eleventh Hour* was another Tony Clarkin design and is a sort of "Last Days" scenario.'

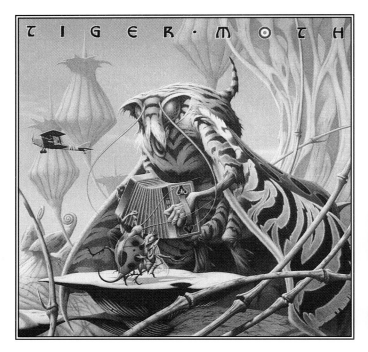

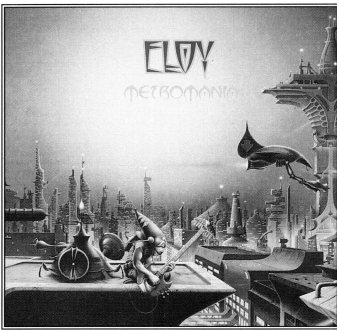

TIGERMOTH 1984
Tigermoth
Rogue Records

METROMANIA 1984
Eloy
Heavy Metal & EMI (Germany)

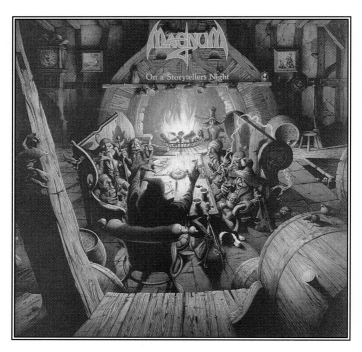

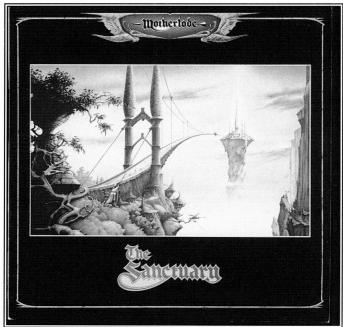

ON A STORY TELLER'S NIGHT 1985
Magnum
FM Records

THE SANCTUARY 1986
Motherlode
Active Records

'*Tiger Moth* is one of my own favourites because of its humour. Ian A. Anderson asked for this type of image after having seen "The Hop" (*Last Ship Home*). *Metromania* is actually my image "Be Watchful" (*In Search of Forever*) but without the face in the sky on the original. *On a Storyteller's Night* is also a favourite of mine and one of my best known images. Again, it was largely designed by Tony Clarkin with his formidable biro! *The Sanctuary* was used by Motherlode from Sweden.'

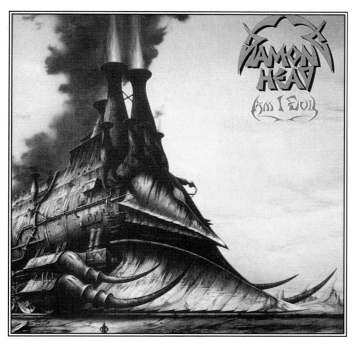

AM I EVIL 1987
Diamond Head
FM Records

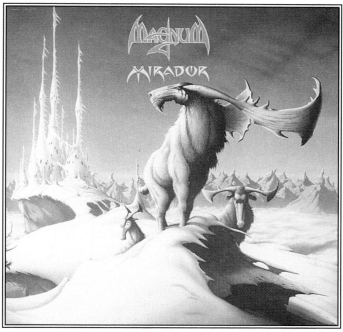

MIRADOR 1987
Magnum
FM Records

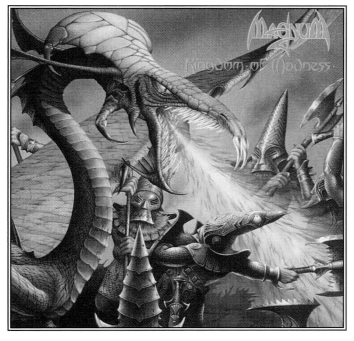

KINGDOM OF MADNESS 1988
Magnum
FM Records

MAGNUM II 1988
Magnum
FM Records

'These images all came to be used on record sleeves by way of second rights sales. *Am I Evil* first appeared as a poster ("The Heavy Metal Hero"), as did *Mirador*; while *Kingdom of Madness* ("The Dwarves of Belegost") and *Magnum II* ("To Steal a Battleship") were both featured in my circular calendars for 1988 and 1990.'

51

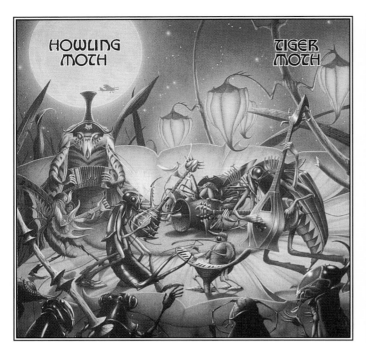

HOWLING MOTH 1988
Tiger Moth
Rogue Records

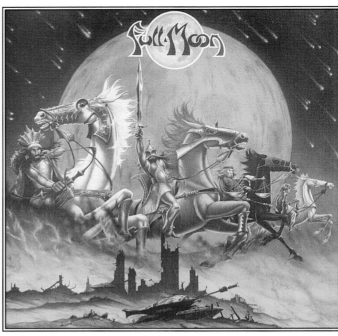

FULL MOON 1989
Full Moon
Voices of Wonder Records

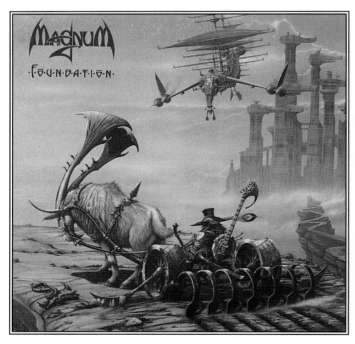

FOUNDATION 1989
Magnum
FM Records

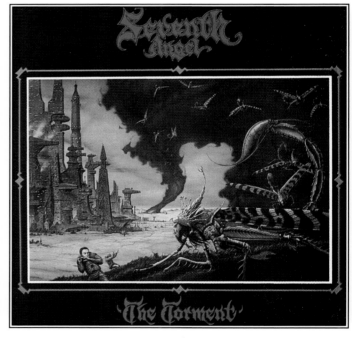

THE TORMENT 1990
Seventh Angel
Edge Records

'One of my favoured themes is to place insects into the role of musicians. Entomology interests me very much, although I would not call myself an expert. *Howling Moth* features a tiger moth, earwig, weevil and cockchafer, together with other miscellaneous insects from the British countryside. The four riders of the apocalypse appear here on the *Full Moon* sleeve, but from a different perspective to "A Voice Like Thunder" (page 89).'

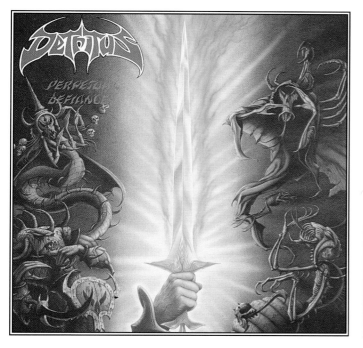

PERPETUAL DEFIANCE **1990**
Detritus
Edge Records & Under One Flag

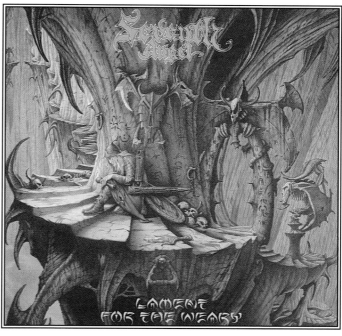

LAMENT FOR THE WEARY **1991**
Seventh Angel
Edge Records & Under One Flag

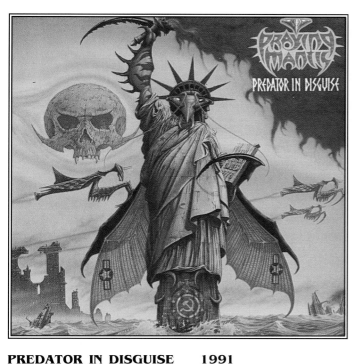

PREDATOR IN DISGUISE **1991**
Praying Mantis
Pony Canyon Records

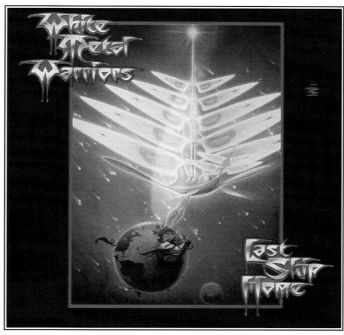

LAST SHIP HOME **1991**
White Metal Warriors (Various Artists)
Edge Records

'It is reputed that *Lament for the Weary* won the Album Cover Design of the Year award in a prominent US Christian Rock magazine, but I was never officially informed. The *Predator in Disguise* cover caused a stir in Japan upon the release of the album. The Japanese were perplexed about the meaning behind the image (see page 17 for an explanation). I was invited to comment on this on a rock radio programme and in a music magazine article.'

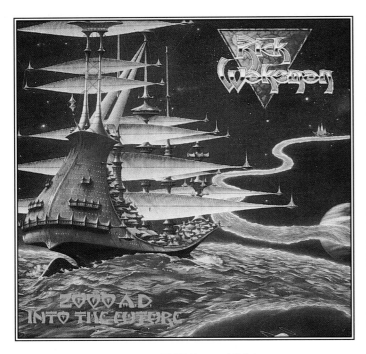

2000ad INTO THE FUTURE 1991
Rick Wakeman
Ambient

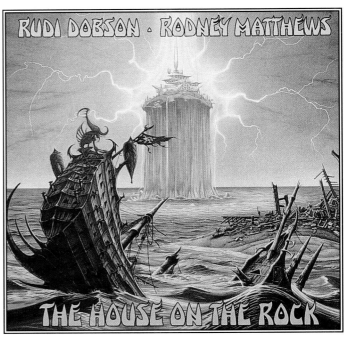

THE HOUSE ON THE ROCK 1992
Rudi Dobson & Rodney Matthews
Officially Yours

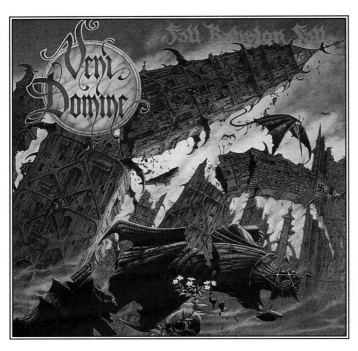

FALL BABYLON FALL 1992
Veni Domine
Edge Records

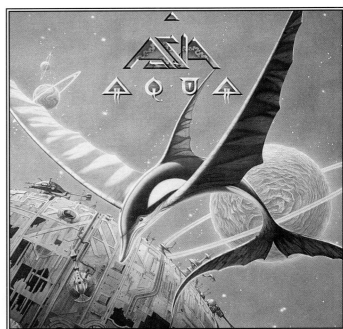

AQUA 1992
Asia
Musidisc UK; Great Pyramid US

'Rick Wakeman selected the "Ether Stream" image for his *2000 AD* album of instrumental music. As a long-standing fan of Rick's, I was more than pleased to be invited to collaborate on this project. The illustration "The House on the Rock" was done with the intention of killing three birds with one stone. I needed it simultaneously for a poster, the cover of *The 2nd Rodney Matthews Portfolio* and the cover of the three-track CD above. The instrumental tracks were written by composer and session musician Rudi Dobson, with Tony Clarkin from Magnum playing guitar and yours truly on drums.'

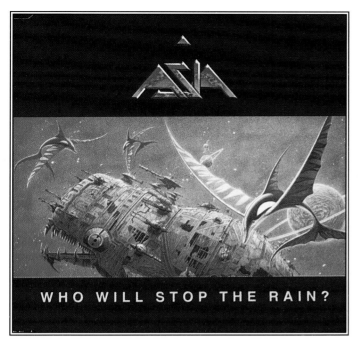

WHO WILL STOP THE RAIN? (Single) 1992
Asia
Musidisc

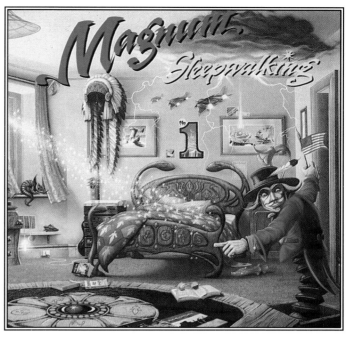

SLEEPWALKING 1992
Magnum
Music For Nations

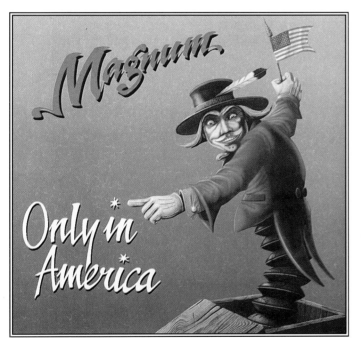

ONLY IN AMERICA (Single) 1992
Magnum
Music For Nations

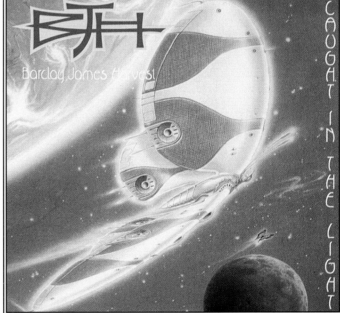

CAUGHT IN THE LIGHT 1993
Barclay James Harvest
Polydor

'Until the eleventh hour the *Sleepwalking* album was to be called *Nightwatch*, which was the title given it in my calendar for 1993. A section of the design was isolated for the single *Only in America*, my favourite track on the album. The song is also featured with Magnum footage on my video *A House on the Rock*.'

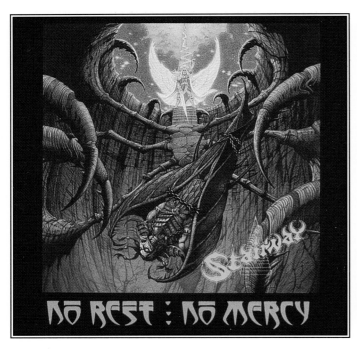

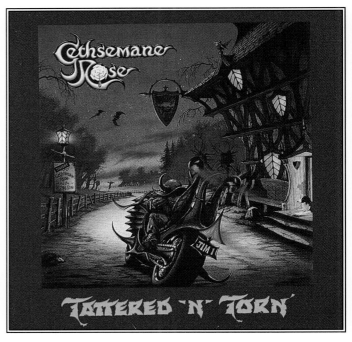

NO REST, NO MERCY 1993
Stairway
Kingsway Music

TATTERED 'N' TORN 1993
Gethsemane Rose
Kingsway Music

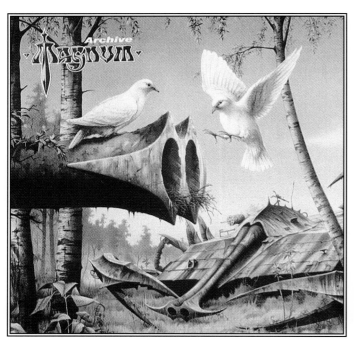

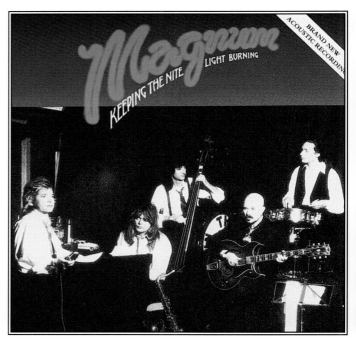

ARCHIVE 1993
Magnum
Jet Records

KEEP THE NITE LIGHT BURNING 1993
Magnum
Jet Records

'Trojan Sales bought second rights on my illustration "Peace... at Last" for use on the *Archive* album. Tracks include "Sea Bird", "Stormbringer" and "Captain America". For the album *Keep the Nite Light Burning* the band asked me to design the lettering. The twelve tracks are Magnum classics played on acoustic instruments.'

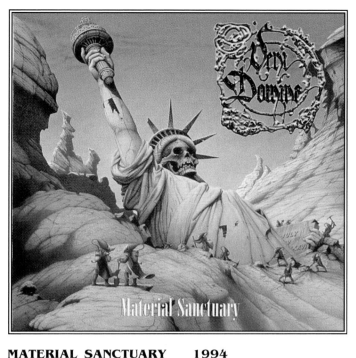

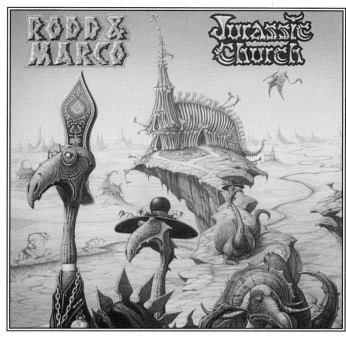

MATERIAL SANCTUARY 1994
Veni Domine
Thunderload Records

JURASSIC CHURCH 1994
Rodd & Marco
Kingsway Music

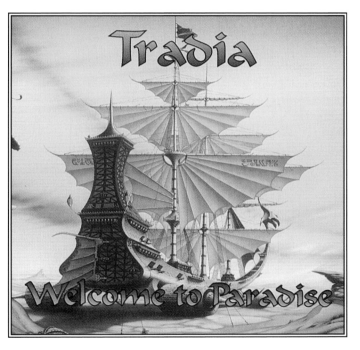

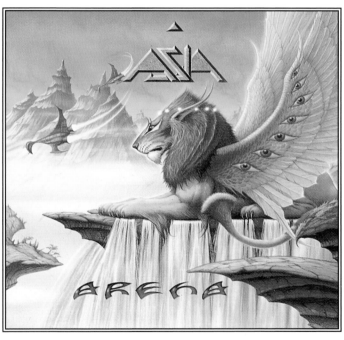

WELCOME TO PARADISE 1995
Tradia
FM Records

ARENA 1995
Asia
Intercord–EMI Germany; Warner Music Japan

'Owners of my first anthology, *In Search of Forever,* will recognize the image on *Material Sanctuary* as "Hysterical History", produced for the band Bronz but never used. Ten years later it found a home on this album by hard-hitting Swedish Christian rock band Veni Domine. Paul Birch of FM bought second rights on "Terrestrial Voyager" for use on the Tradia album cover. Plenty has already been said about *Jurassic Church* and *Arena.*'

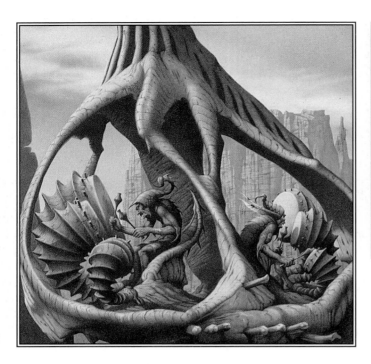

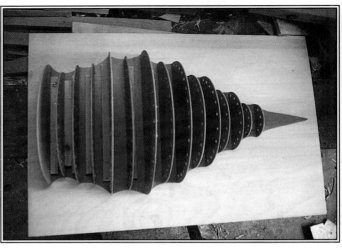

Plywood pattern for fibreglass drum mould

DRUMTOWER 1984
Inks. 38 x 38cm

'It must have been some time in 1984 when I decided to construct a Matthews custom drum kit. Some of my pictures had already featured unusual drums, as in the "Drumtower" image above, so why couldn't I have the real 3-D kit? My first idea was to make the beehive-shaped sound box in two halves and stick them together, forming the basic pattern. A mould could then be made by fibreglass expert Gary Pullen in Somerset. My first attempt is shown above. Later I found it was quicker to make the whole pattern using circles cut from hardboard and joined round a central pole. I then filled the inside spaces with compacted newspaper and formed each concave ring by drawing filler around the body of the drum with a template.

'The kit was completed to its present stage in about 1993, but I may still add to it. The bass drum is 22 x 33in (56 x 84cm), with 13in and 14in toms (33cm and 36cm), and an 18 x 24in (46 x 61cm) floor-standing tom-tom. I currently use a conventional snare to complete the basic kit, but the photographs below also show my 12in and 14in (31cm and 36cm) prototype drums.'

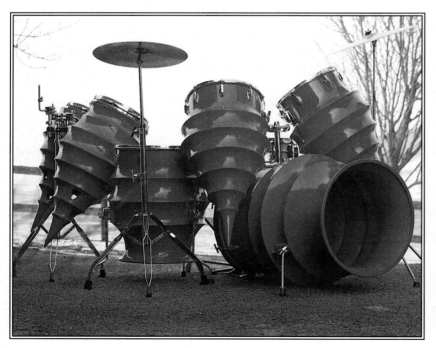

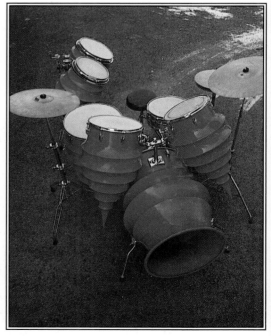

SECTION 2 : BOOKS

Book covers and illustrations have exercised Rodney Matthews' imagination as much as music over the years. He remains as active in this area as ever, as shown both by the Stephen Lawhead covers and Matthews' illustrated *Tales of King Arthur* included in this section.

The breakthrough came in 1976 when Michael Moorcock asked his publishers to secure Rodney Matthews as cover artist for *The End of All Songs*, the third in his 'Dancers at the End of Time' trilogy. This led to a strong friendship and some very creative teamwork, culminating in 1981 with the illustrated tale *Elric at the End of Time*, which Moorcock tailored to suit Matthews' visuals.

In the meantime Matthews' brush was also in demand for illustrating other top-flight authors, including A. Merritt, André Norton and Clark Ashton Smith; and 1978 saw the publication of Matthews' own illustrated tale *Yendor*, which can now also be perused in its entirety on the CD-ROM *Between Earth and the End of Time*.

The three Stephen Lawhead covers that follow are for titles in the 'Song of Albion' trilogy. Lawhead is an American author based in England whose work is deeply rooted in the Celtic mythology of the British Isles. He naturally loves North Wales where the artist lives and they have ended up becoming friends, which is less common than might be supposed. Contact between author and cover artist is more usually confined to the printed page and the mediation of a third party. Both are Christians, which no doubt partly explains it, and this shared belief surfaces in a detail of *The Silver Hand* (page 61). The four horses in the foreground mirror those of the Apocalypse, the pale steed of Death taking the lead. However, having the procession rising towards the viewer instead of dwindling into the distance (see the accompanying sketch) was one of those editorial decisions all illustrators have to live with from time to time.

'Treebeard' (page 63) was Matthews' contribution to a volume entitled *The Tree* edited, aptly enough, by Peter Wood. Profits from this project went to The Woodland Trust, the charity dedicated to rescuing and managing threatened areas of native woodland. Having been a great nature lover all his life, Matthews might have chosen to do a straight painting of some unusually weird or beautiful tree, but the temptation to show a scene from Tolkien was irresistible. So here we have the point in *Lord of the Rings* where Merry and Pippin meet their first Ent, Treebeard, as Rodney pictured the scene on first reading the book. Treebeard is shown as an animated Silver Birch, a variety whose upper branches (or in this case, arms) grow fresh and supple no matter how ancient the tree.

One extra bonus from this assignment was meeting entrepreneur Chris Beetles at an associated exhibition, and at last finding a regular gallery outlet in London. Admirers of Rodney's work include John Cleese and Lord Jeffrey Archer.

THE PARADISE WAR
1990
Inks. 43 x 21cm
Author: Stephen Lawhead
Publisher: Lion Books

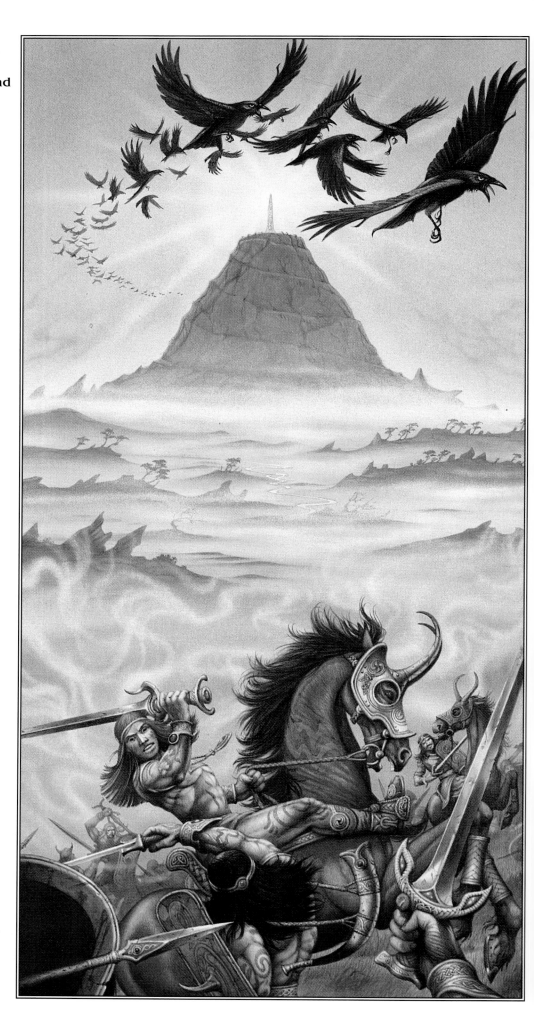

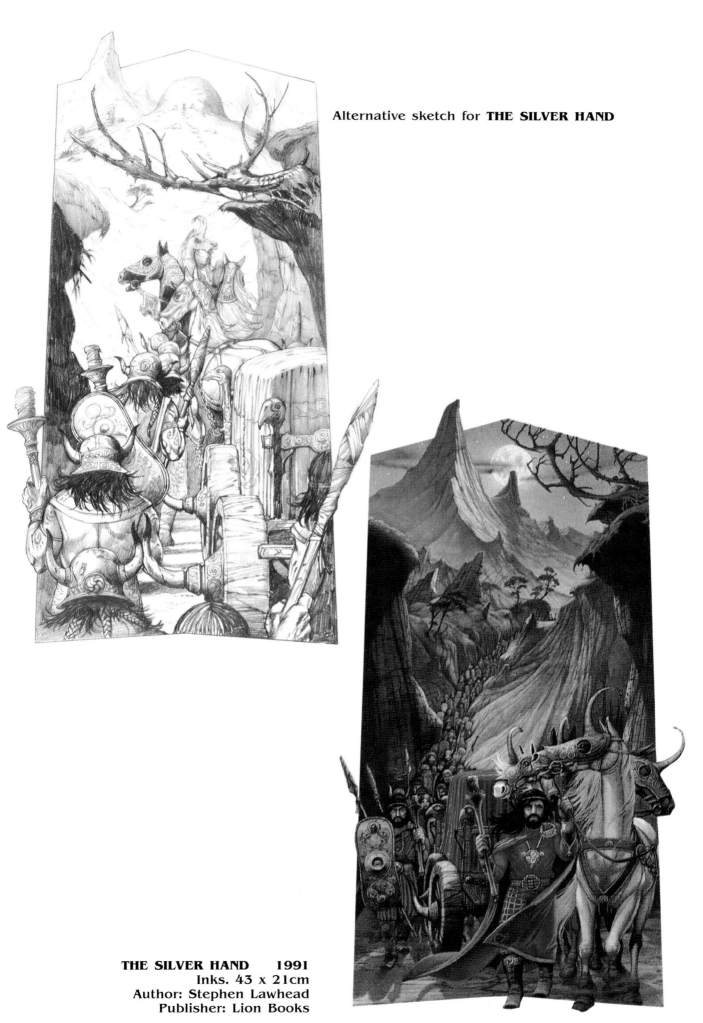

Alternative sketch for **THE SILVER HAND**

THE SILVER HAND 1991
Inks. 43 x 21cm
Author: Stephen Lawhead
Publisher: Lion Books

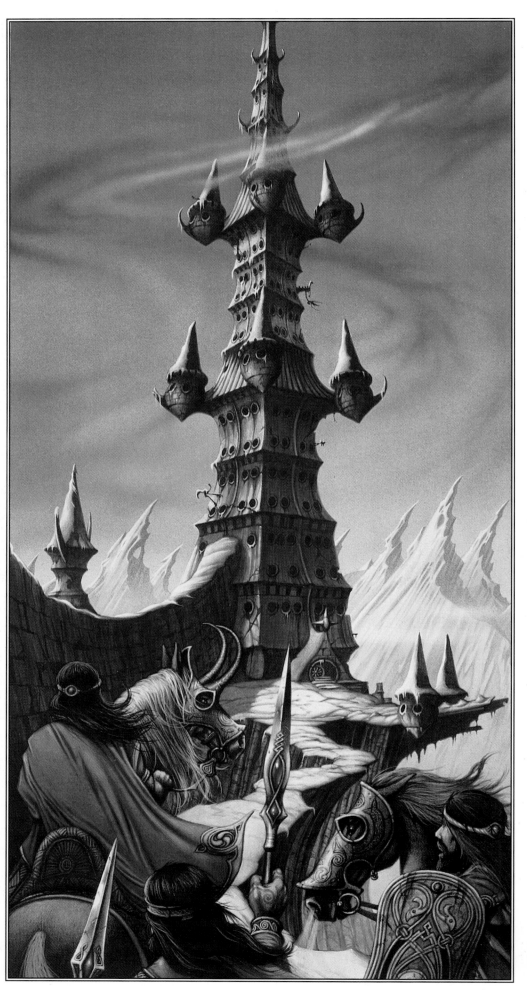

Page 63 **TREEBEARD**
1989
Inks. 58 x 40cm
Author: J. R. R. Tolkien
Publisher:
David & Charles

THE ENDLESS KNOT
1992
Inks. 43 x 21cm
Author: Stephen Lawhead
Publisher: Lion Books

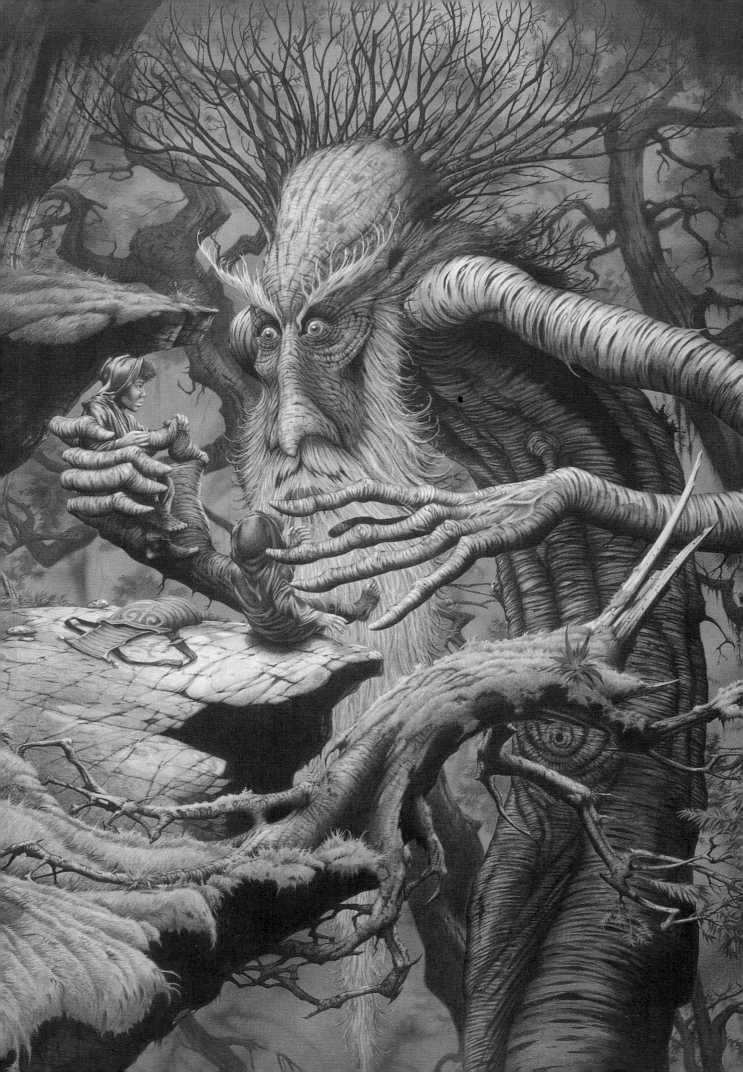

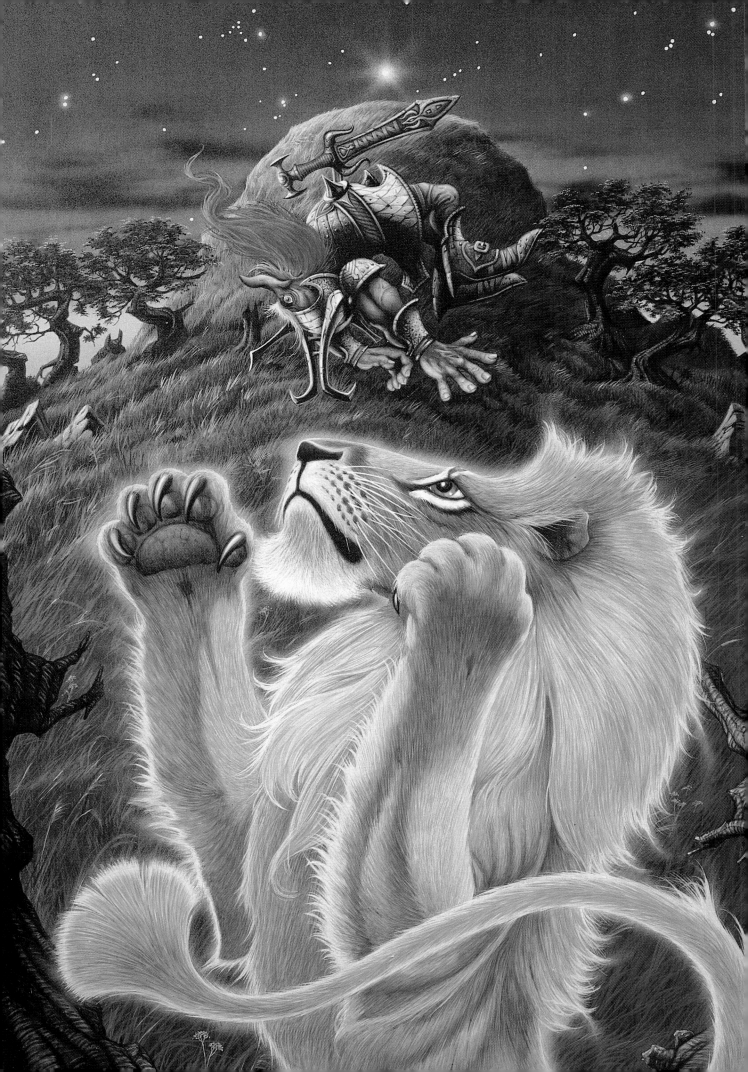

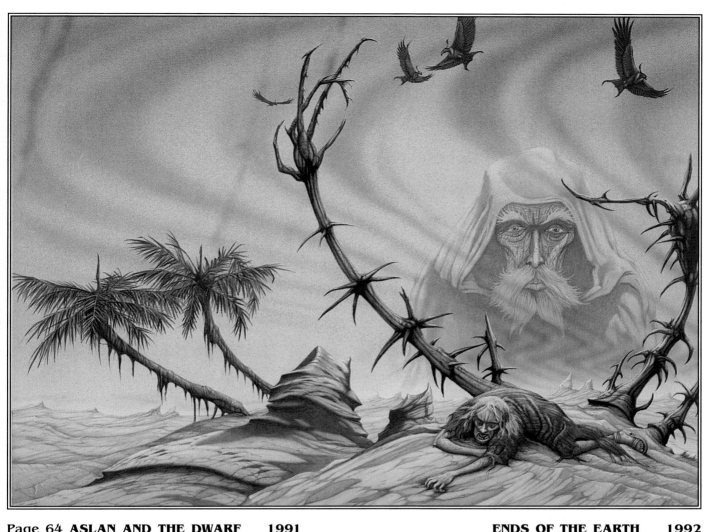

Page 64 ASLAN AND THE DWARF 1991
Inks. 48 x 30cm
Author: C. S. Lewis. *Prince Caspian*
School exercise

ENDS OF THE EARTH 1992
Inks. 26 x 36cm
Author: Naomi Starkey
Publisher: Minstrel – Kingsway

Unusual requests often come Matthews' way. One was being asked by a school in nearby Wrexham if he could run an arts workshop with the pupils for a week. The guidelines were quite loose: 'Set them a subject and supervise.' So the class was told to design a hypothetical book cover based on a choice of three scenes from C. S. Lewis' 'Chronicles of Narnia'. While the children worked, Matthews went around dispensing hints on how to go about it, such as: (1) read and understand the text, (2) leave space for lettering, and (3) try to get your point over with a bold, simple design that will hopefully catch the browser's eye and encourage them to pick the book up, which of course is the object of the exercise.

Meanwhile, Matthews painted 'Aslan and the Dwarf' (opposite) to show how a professional would go about it. Note the contrast between the radiant lion and dark sky, which makes Aslan stand out that much more. The blank lettering area has been cropped for reproduction here.

'The Rainbow Room' (page 66) is a rare example of an almost purely technical Matthews illustration. Commissioned by a Swedish music-related mail order company for its catalogue, the aim was to include as many of their products as possible, which include the Rodney Matthews poster on the wall. As in all such cases, it was repainted in miniature as he dislikes sticking foreign objects onto his pictures.

THE RAINBOW ROOM 1993
Inks. 48 x 36cm
Publisher: Skivor & Band

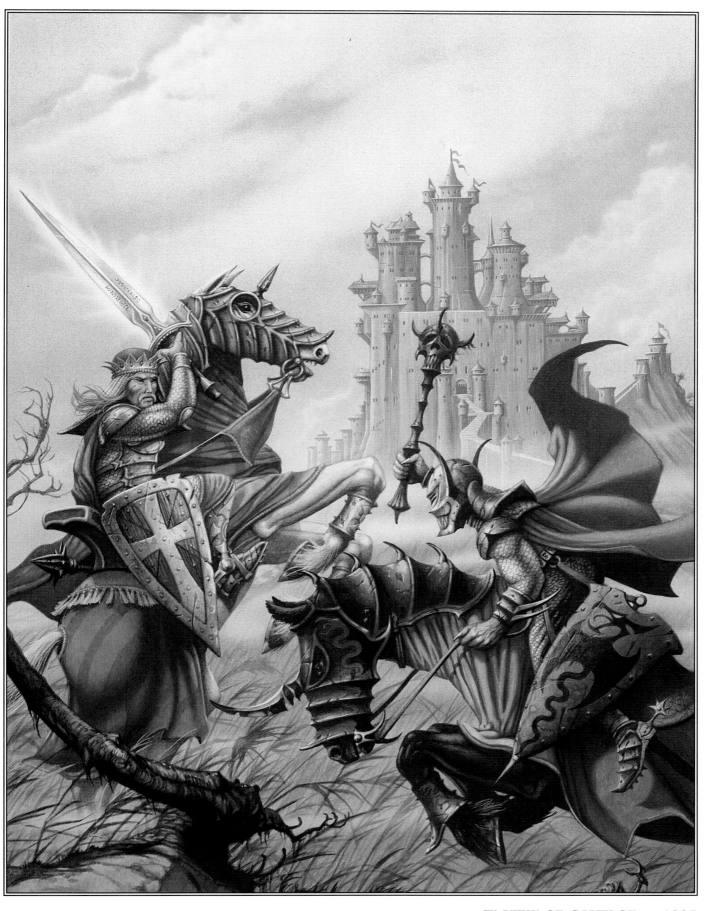

IN VIEW OF CAMELOT 1993
Inks. 30 x 22cm
Author: Felicity Brooks *Tales of King Arthur*
Publisher: Usborne

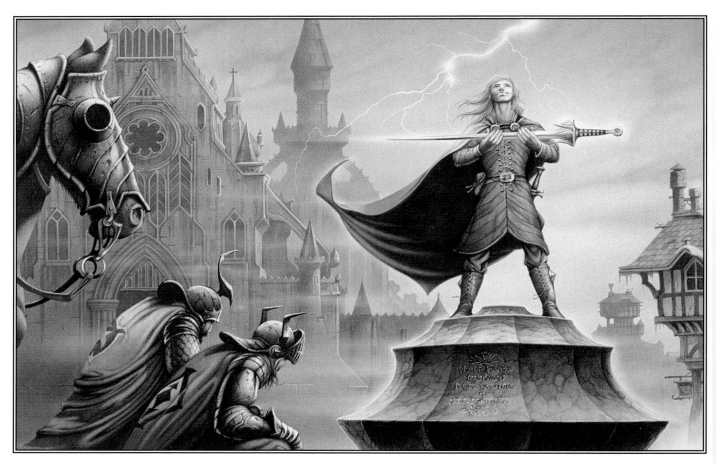

THE SWORD IN THE STONE 1994
Inks. 24 x 37cm
Author: Felicity Brooks *Tales of King Arthur*
Publisher: Usborne

The tales of King Arthur have been illustrated so often that a certain late Medieval look has come almost to be expected. Usborne wanted a fresh look for their edition, however, something that was neither conventional nor strictly historically accurate, so Matthews was approached for a trial cover picture. This was then taken to the Frankfurt Book Fair to test responses, and the whole thing depended on favourable reactions.

The book is a Fantasy version of Arthur's tale, retold by Felicity Brooks. There were limits to the fantasy, though. For instance, Matthews says, 'I used a book on Medieval armour as a basis but then took the designs further. You can go too far, but who's to know if some bright spark of an armourer didn't make such things in the past? Only so much has survived in museums, all kinds of other things were possible. Knowing where to start and stop is the secret.'

He is not generally much drawn to mythology but the Christian theme of the Arthurian tales makes them an exception, clouded though the theme often is. His home environment also helps – from the hilltop just behind Matthews' home can be seen the Aran, the highest local mountain. Local legend has it that in a cave within the mountain lie Arthur, Merlin and the Knights of the Round Table, awaiting the call of their kingdom's darkest hour. This is the scene of the book's last illustration. Also

EXCALIBUR 1994
Inks. 24 x 37cm
Author: Felicity Brooks *Tales of King Arthur*
Publisher: Usborne

visible from that hilltop is Cader Idris, of which it is said that anyone who spends a night alone on the summit will return either mad or a poet.

This book was the most satisfying Matthews had illustrated throughout since *Elric at the End of Time* in 1981, despite a working pace that required one colour illustration a week and up to three black and white ones a day. It also brought back childhood memories of manufacturing swords and armour in his father's workshop and then charging off to do mock battle with friends. Some of the weapons were quite lethal so, although the battles were faked, often the injuries were not!

'Excalibur' (above) was a pleasure in its simplicity and in the chance it gave simply to paint a beautiful landscape. The point of the picture on page 70 is that the two swords are identical. Arthur, on the right, has been tricked into using worthless replicas of his own invincible sword and almost equally charmed scabbard, which have instead been given to his opponent. Both knights have been tricked into believing they are fighting a mortal enemy, whereas in fact they are the best of friends. The agent behind all this deception is, of course, the sorceress Morgan le Fay who is hoping to see Arthur die. The moral perhaps is that one should check behind the enemy's visor before doing battle, rather than after as happens in this tale.

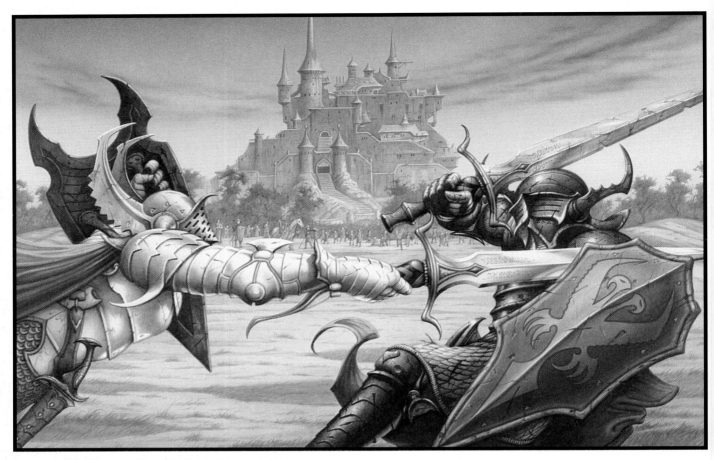

KING ARTHUR & SIR ACCOLON 1994
Inks. 24 x 37cm
Author: Felicity Brooks *Tales of King Arthur*
Publisher: Usborne

Sir Pellinor **The Barge**

SECTION 3 · PRINTS AND COMMISSIONS

One frustration of an illustrator's life is the lack of outlets in which to display and sell original paintings. It is generally a matter of chance when the artist's path crosses that of an interested buyer. Matthews has suffered as much as anyone from this, and in the past his approaches to galleries have generally been rebuffed on the grounds that the work won't sell. So it was a real find running into Chris Beetles, who had loaned his gallery for the launch of the book containing Matthews' 'Treebeard' (page 63).

The Beetles Gallery in London specializes in what might loosely be described as English watercolour illustrations of English children's authors, handling artists such as Rackham, Dulac, Edward Lear and Mervyn Peake. (Also, forever defying categorization, Russell Flint.) Chris Beetles is himself an expert in the field, with several books to his credit and, according to Rodney, the ability to even tell you what colour socks the artist was wearing during the creation of any particular painting. His choice of what goes into the gallery is very personal and, as it does not include many contemporary artists, Matthews felt quite honoured to be taken on board. Gallery clients include the rich and famous, a Greek shipping magnate or two and a brace or more of Monty Pythons. John Cleese has bought four Matthews originals, about one of which he told the artist, 'I just had to have it. I don't know why I love it so much, there's just something about it I find absolutely hypnotic.' Terry Jones, also the owner of a Matthews original, wrote the appraisal for his 1988 calendar.

The four limited edition 'Alice' prints shown on the following pages were partly what attracted Chris Beetles to Rodney's work. They were issued in runs of 750 signed, numbered and embossed copies which the artist rates as the best printing yet of his work, so buyers get more than rarity value for their money. Beetles commissioned several more which helped Matthews fulfil a long cherished dream of illustrating the tales throughout, as they have given him enormous pleasure since childhood.

Is he not daunted by those who have done it before? 'Not really, because I don't think competitively about it. I don't compare what I'm doing with Tenniel or Rackham, and it doesn't destroy my pleasure knowing there have been other approaches. Many people can't separate the 'Alice' stories from Tenniel's drawings because that's how they first read them, but a greater influence for me was the original Disney film which I saw at the age of seven. It wasn't a great commercial success but for me it was a revelation, and in a way the impression it made is resurfacing in my own pictures all these years later. Apart from Disney, my own favourite 'Alice' illustrator is Arthur Rackham, but my approach is almost as if Lewis Carroll were writing today. I'd jump at the chance of illustrating him.

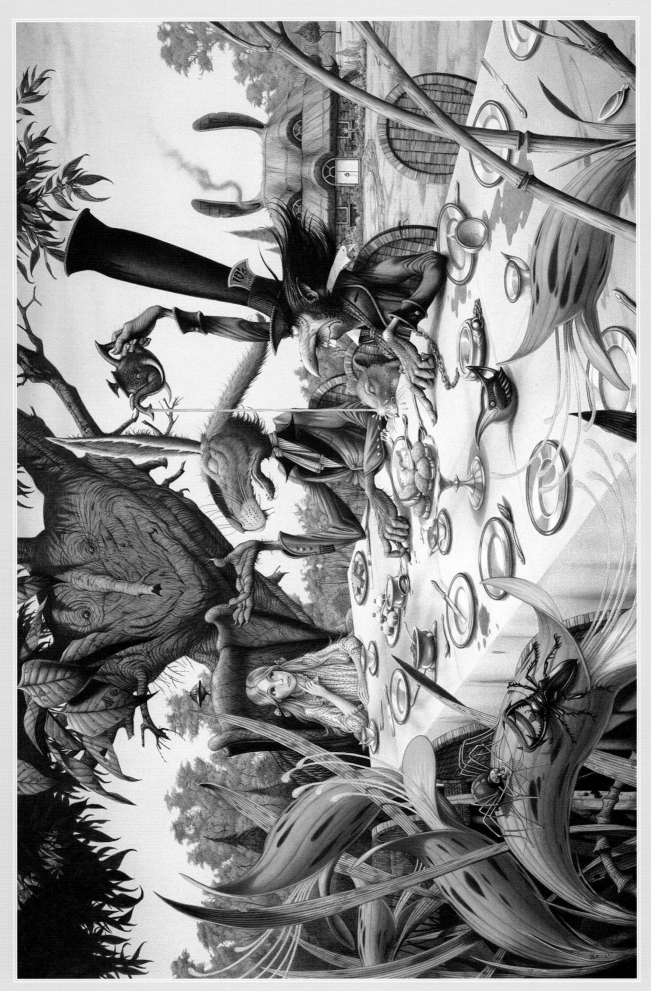

AT THE MARCH HARE'S TABLE 1990
Inks. 35 x 55cm
Author: Lewis Carroll. Publisher: Cartouche Fine Art

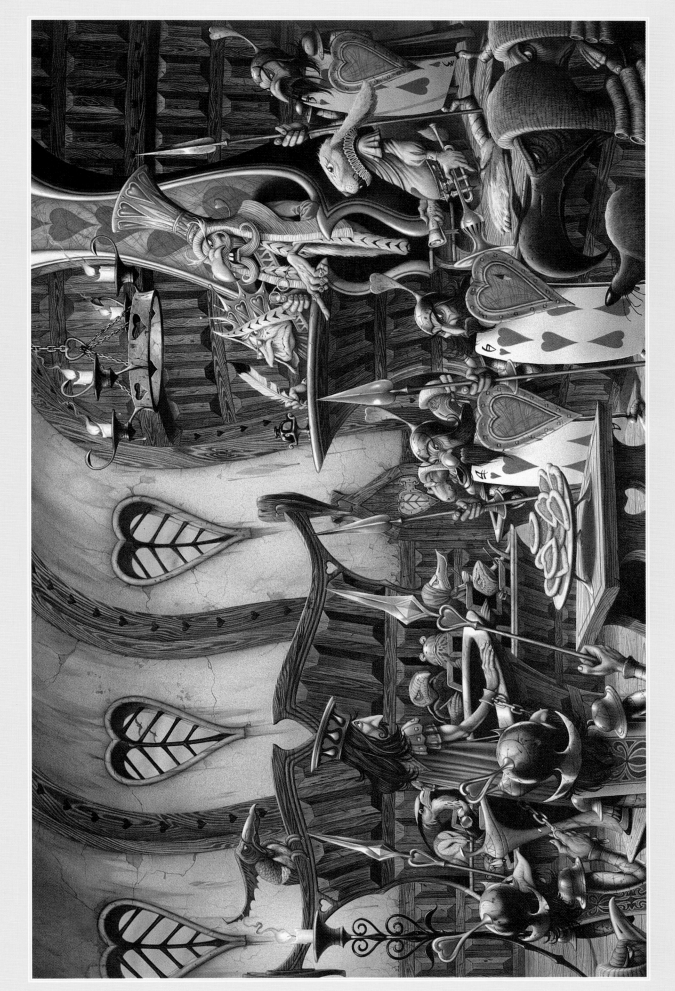

THE KNAVE ON TRIAL 1990
Inks. 35 x 55cm
Author: Lewis Carroll. Publisher: Cartouche Fine Art

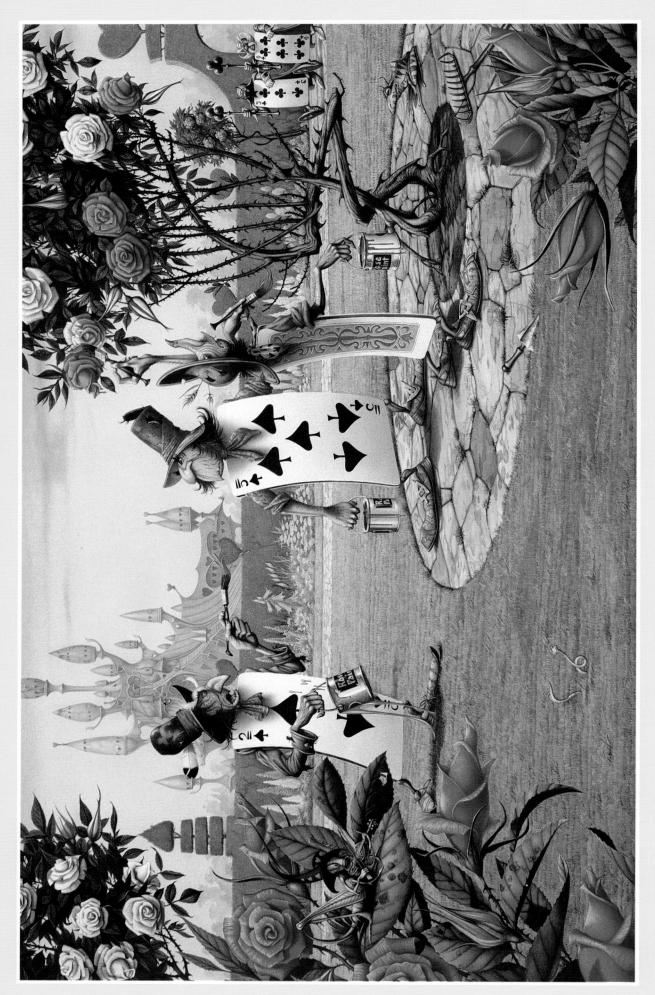

PAINTING THE ROSES 1990
Inks. 35 x 55cm
Author: Lewis Carroll. Publisher: Cartouche Fine Art

ON THE CROQUET GROUND 1990
Inks. 35 x 55cm
Author: Lewis Carroll. Publisher:Cartouche Fine Art

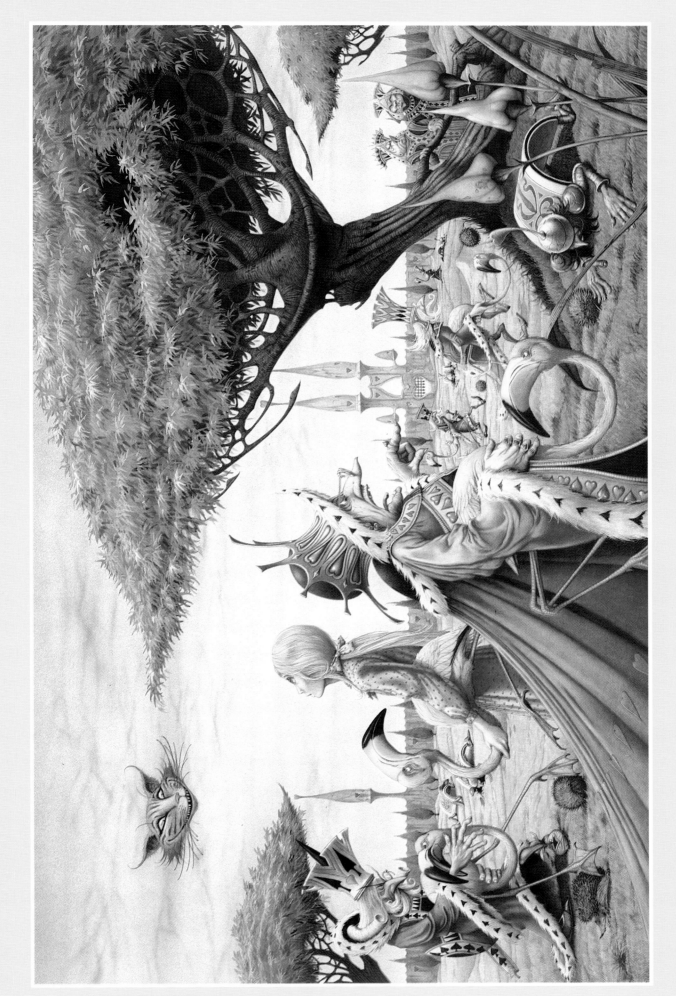

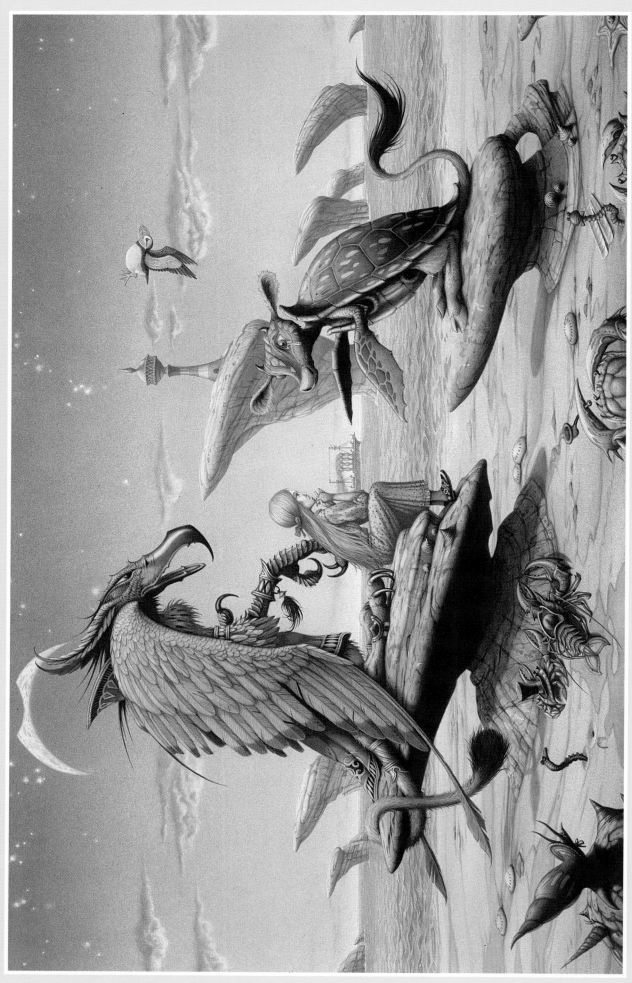

THE MOCK TURTLE'S STORY 1994
Inks. 35 x 55cm
Author: Lewis Carroll. Publisher: The Ink Group

76

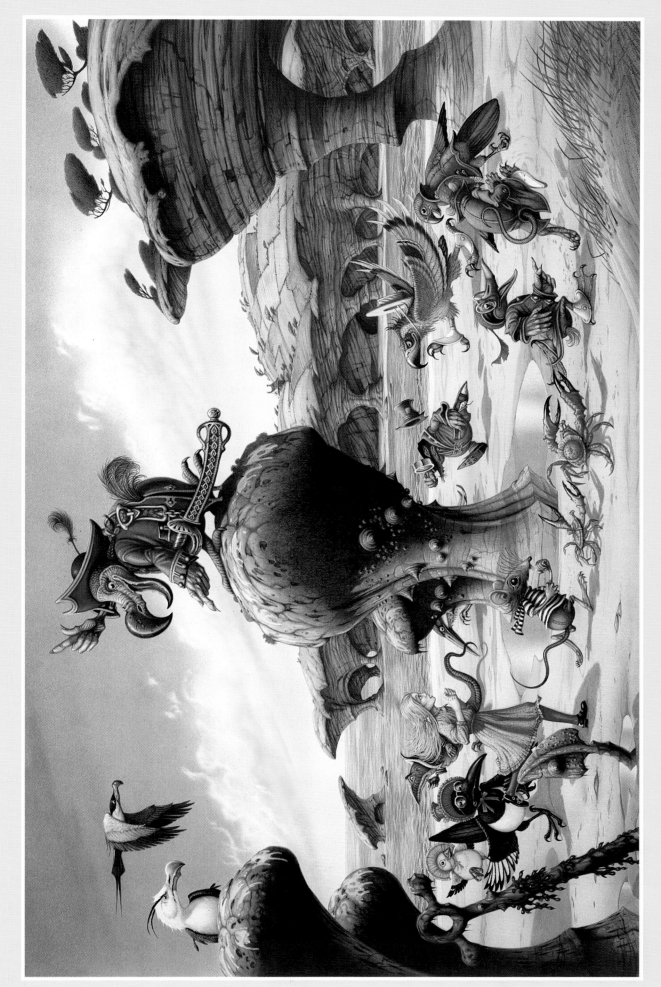

A CAUCUS RACE 1994
Inks. 35 x 55cm
Author: Lewis Carroll. Publishers: The Ink Group and Wizard & Genius

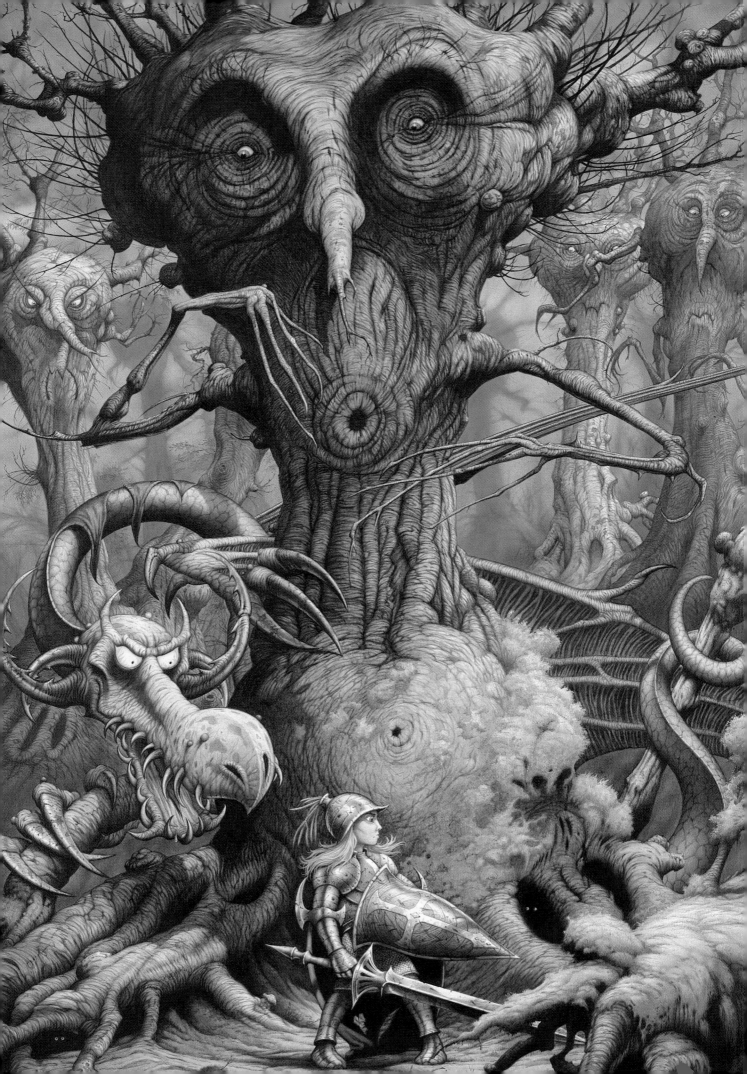

Matthews describes the style of the pictures he sells through The Beetles Gallery as: 'Illustration as opposed to Fantasy art. It is deliberately whimsical whereas in Fantasy art the subjects are generally treated in a dead serious way, even though you know they are make-believe. If you're painting a dragon, the aim is to make it look real.' Unlike the creature opposite which, for all the spark in its eyes, is unlikely to give anyone nightmares.

'Jabberwocky' was Matthews' response to a request from Wizard & Genius Posters of Zurich for something along the lines of 'Treebeard'. Guessing that what they were after was another animated tree, these lines from *Through the Looking Glass* came to mind:

'So he rested by the Tumtum tree
And stood awhile in thought.
And, as in uffish thought he stood,
The Jabberwock, with eyes of flame,
Came whiffling through the tulgey wood,
And burbled as it came!'

The piece was invited to an exhibition staged at Machynlleth, North Wales by the Museum of Modern Art, entitled 'These Enchanted Woods'. It failed to receive any award from the official judges but did receive the Ailsa Owen Memorial Prize for being the most popular picture in the exhibition, as voted by the visitors, which certainly proves something! Although commissioned as a poster, the painting was designed as an exhibition piece in order to kill two or more birds with one stone.

On the following pages, some rather more serious pictures on spiritual themes appear. Matthews himself does not consider them to be 'religious art', a category of which he is decidedly wary. In fact, even the term 'religious' is one he shies away from in relation to his own beliefs, because of its association with the warring creeds that still create so much misery in the world. These pictures are, however, closely tied to the scriptures and his own perception of Christianity.

'Fear No Evil' (page 80) is a personal view of the Valley of the Shadow of Death described in Psalm 23. What you see is the invisible world surrounding the pilgrim in the centre, whose fleshly eyes are only aware of the street, campus or other everyday path he is simultaneously negotiating. For this concept of intermingling realities, Matthews acknowledges a debt to the novels of Frank Peretti in which angels and demons wage mostly invisible war in the world for human souls. For this and similar pictures, both were carefully researched from visionary testimony. 'A to Z of the Supernatural' (page 81) was designed as a chart with explanatory labels alongside. It is more schematic than Matthews would naturally have chosen, but the compromise worked quite well. At the top, of course, are God and his angels. Below them stands Satan, who is banned from the top level of Heaven. Below them we see humanity from the days of Adam to the present, beset by the lower evil spirits, such as Lust in the spiritual form of a frog. At the bottom we see Creation as it is, beautiful but in a fallen state as indicated by the scorpion and praying mantis. From beneath the throne flow the waters of mercy, hedged by the fires of judgement that await those who use mercy to its limit.

Matthews' talent for depicting demons does not always meet with approval from other Christians. In an exhibition at the Crossfire festival of Christian music in Liverpool, one irate visitor complained to the security guard that the pictures were demonic. The guard (yes, they have them even at such events) pointed out that most of the demons were being lashed with fiery swords, cast into pits or otherwise having a hard time, but the critic was not really convinced. Matthews himself has no qualms however, and is only too glad to have found a healthy outlet for something that comes naturally to him.

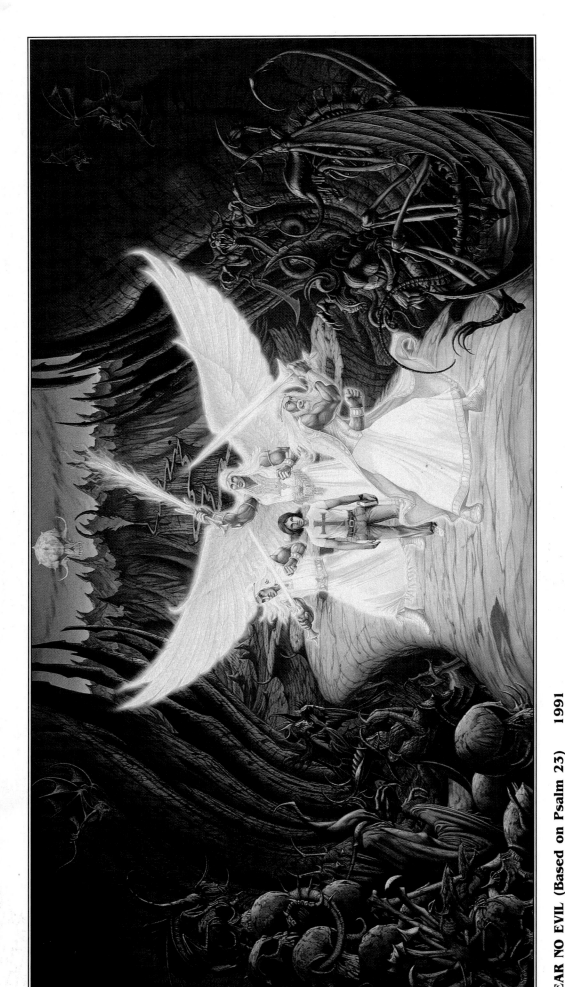

FEAR NO EVIL (Based on Psalm 23) 1991
Inks. 50 x 100cm
Publisher: Officially Yours

A TO Z OF THE SUPERNATURAL 1989
Inks. 54 x 39cm
Publisher: CRO & Sunrise

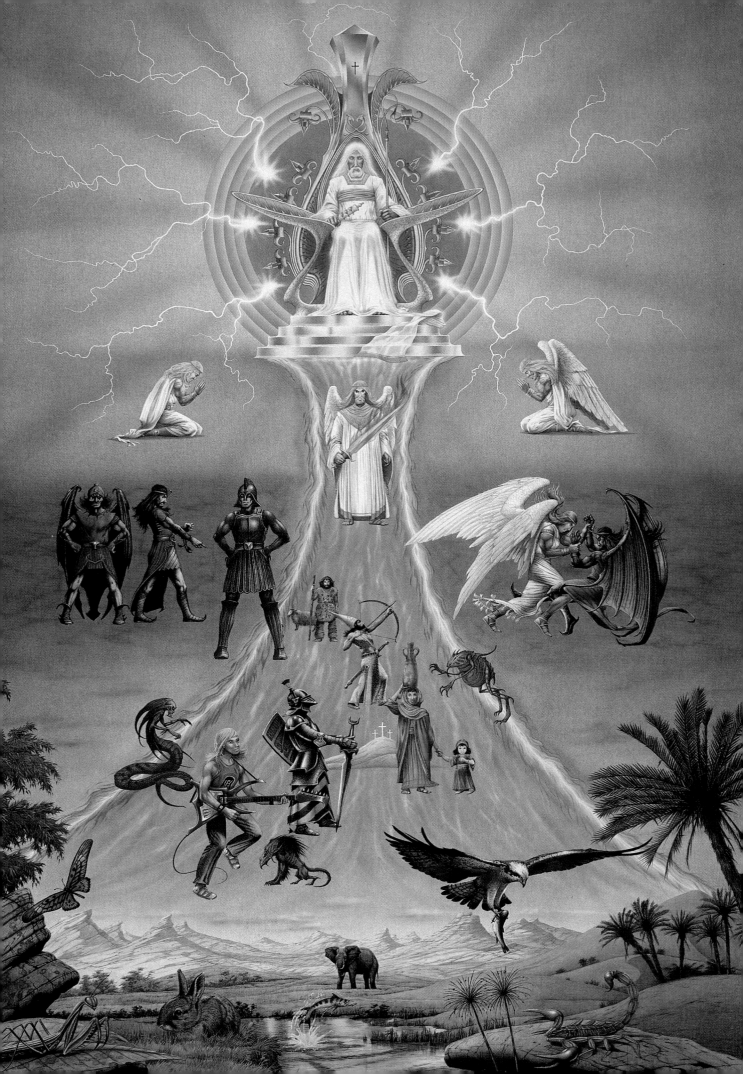

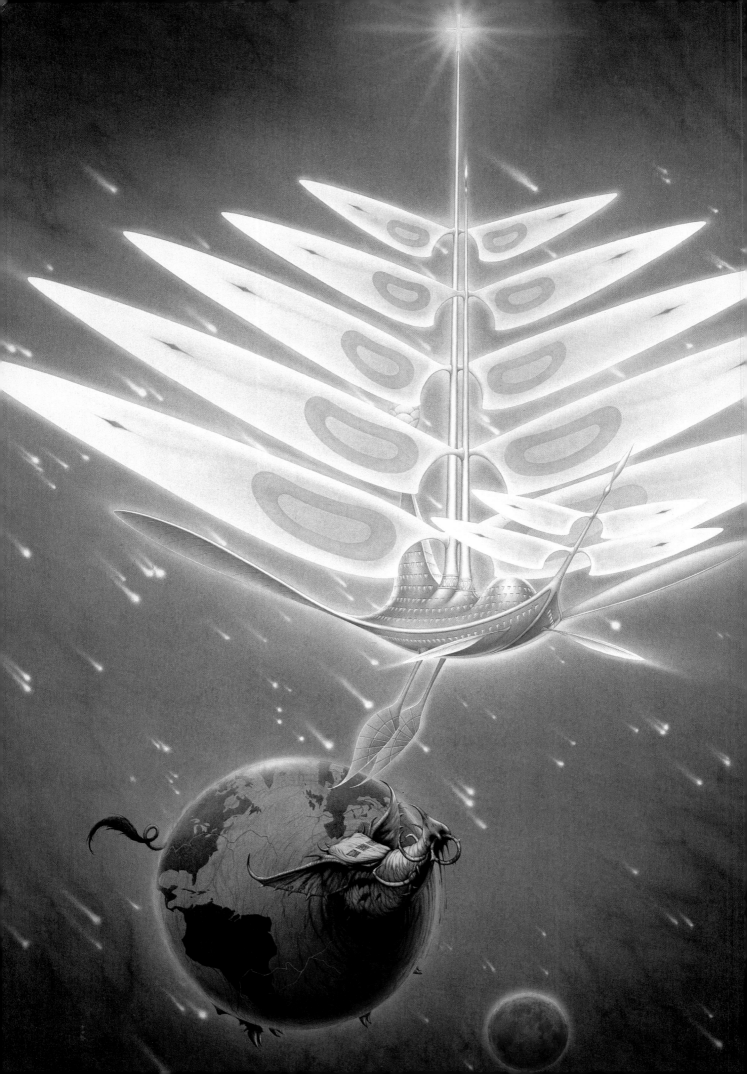

Page 82
LAST SHIP HOME (III) Deliver Us From Evil 1990
Inks. 100 x 70cm
Publisher: Officially Yours

LEVIATHAN 1993
Inks. 36 x 36cm
Publisher: Officially Yours

What needs to be borne in mind with Matthews' more apocalyptic paintings is that they are largely symbolic of Bible events. 'Last Ship Home (III)' shows the ship of the Holy Spirit removing true believers from the face of an earth now in the hands of the Antichrist (I Thessalonians 4 & 5). Similarly 'The House on the Rock' (page 84) is symbolic of the scripture from Matthew 7:24-25: 'Therefore everyone who hears these words of mine and puts them into practice is like a wise man who built his house on the rock. The rain came down, the streams rose, and the winds blew and beat against that house; yet it did not fall, because it had its foundation on the rock.' 'Leviathan' (above) is Matthews' impression of the creature in Job 41.

Page 84
THE HOUSE ON THE ROCK
(Based on Matthew 7:24–27) 1992
Inks. 70 x 48cm
Publisher: Officially Yours

COULD THIS BE REVIVAL? 1994
Inks. 50 x 35cm
Private Commission

PUDDLEGLUM THE MARSH WIGGLE 1994
Inks. 41 x 41cm
Author: C. S. Lewis *The Silver Chair*
Publisher: The Ink Group

'Could this be Revival?' (page 85) was the result of a private commission with Matthews simply being asked to paint something with a church in it. It expresses his opinion of the current state of the established Church of England. A possible subtitle was 'Looks like the Bishop's been blaspheming again.'

After having been introduced to the writings of C. S. Lewis by his wife Karin in the late 1970s, one of Rodney's regrets is having missed out on his work as a child. He has made up for it since and loves painting characters like Puddleglum (above). Note the bittern pretending to be a reed, as they have a habit of doing. The setting is reminiscent of the fens and marshes of Somerset, Matthews' first home. The picture was originally commissioned by the Beetles Gallery.

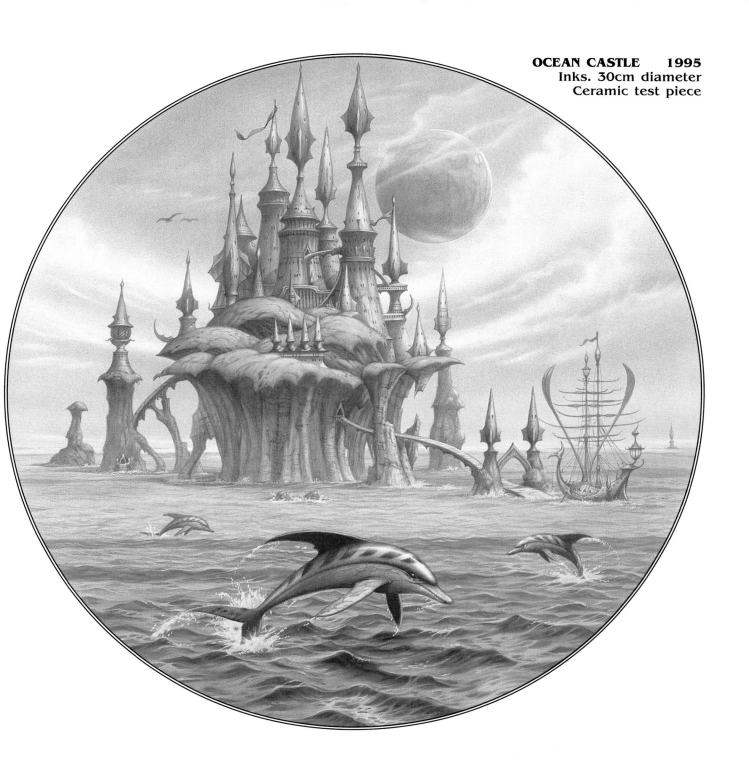

OCEAN CASTLE 1995
Inks. 30cm diameter
Ceramic test piece

A possible new avenue for Matthews is that of having his designs glazed onto collectors' plates. Above is an experimental piece commissioned by MBI (UK), an offshoot of a large American company. The idea is to test responses and perhaps proceed with a set of twelve designs, each featuring some kind of fantasy castle with a mildly unusual creature in the foreground. As with any new venture, the artist hopes to reach a different audience than usual, and the plates are likely to be advertised in mainstream newspapers and magazines.

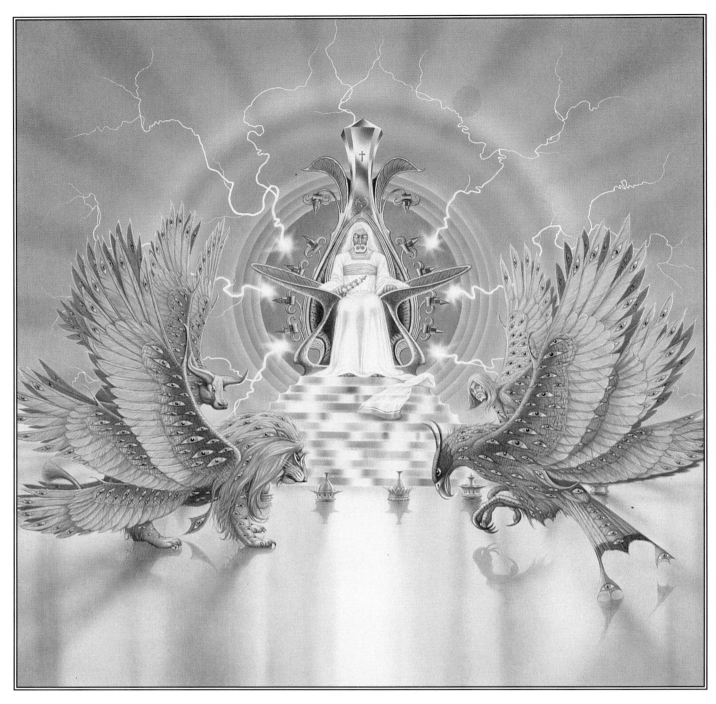

THE REVELATION
THE THRONE IN HEAVEN 1992 Inks. 41 x 41cm
*'The first living creature was like a lion, the second was like an ox, the third
had a face like a man, the fourth was like a flying eagle. Each of the four
living creatures had six wings and was covered with eyes all around, even
under his wings.'* (Revelation 4:7–8)

The following series of images is Rodney's side of a joint venture with composer Rick
Wakeman; twelve paintings to match twelve pieces of music based on passages from
the last book of the Bible. The images are spaced as evenly as possible through the
text, depending on scenes that suit Matthews' style. For the image of God on the
throne, above, Matthews apologizes in advance. Never having seen God for himself,
this is just the best he can do.

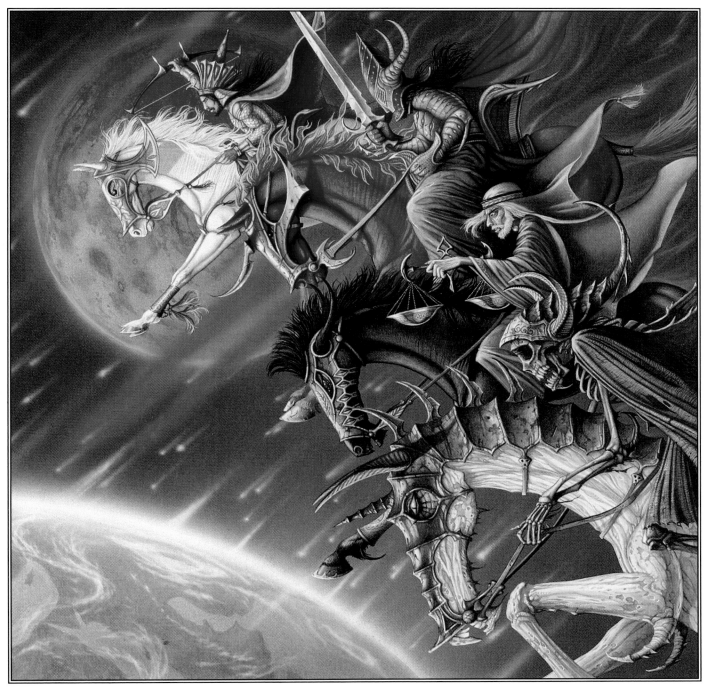

A VOICE LIKE THUNDER **1993**
Inks. 41 x 41cm
*'I looked, and there before me was a pale horse! Its rider was named Death,
and Hades was following close behind him. They were given power over a
fourth of the earth to kill by sword, famine and plague, and by the wild
beasts of the earth.'* (Revelation 6:8)

Above is a reworked version of an earlier picture shown in *Last Ship Home*. The four
riders represent, in the artist's view, the essences of the Antichrist's activities in the
last days. That is, he believes it is unlikely they will ever appear in quite this form,
riding out of the sky, because they are quite possibly here already, invisible but very
active. Note the red moon of the Last Days prophecy, which appears in a number of
other Matthews paintings.

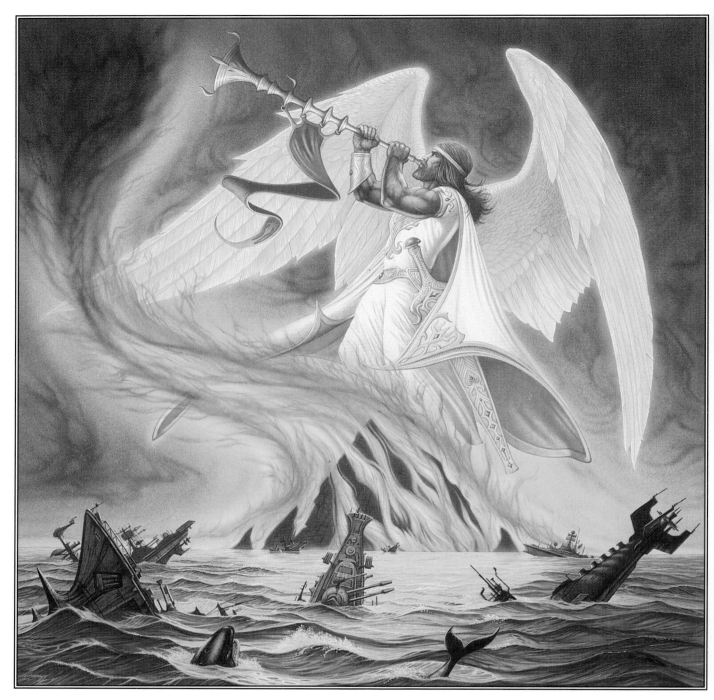

THE SECOND SOUNDING **1992**
Inks. 41 x 41 cm
'The second angel sounded his trumpet, and something like a huge
mountain, all ablaze, was thrown into the sea. A third of the sea turned
into blood, a third of the living creatures in the sea died, and a third of
the ships were destroyed.' (Revelation 8:8–9)

The Revelation is a notoriously tricky book to decipher, but there is a wide consensus among Christians that the world stands on the edge of seeing some of the more dramatic prophecies come true. Rodney has his own suspicions about what is signified by the sounding of the second trumpet, but has decided it would be prudent to keep them to himself. Thanks is owed to Anthony Middleton for posing as the angel.

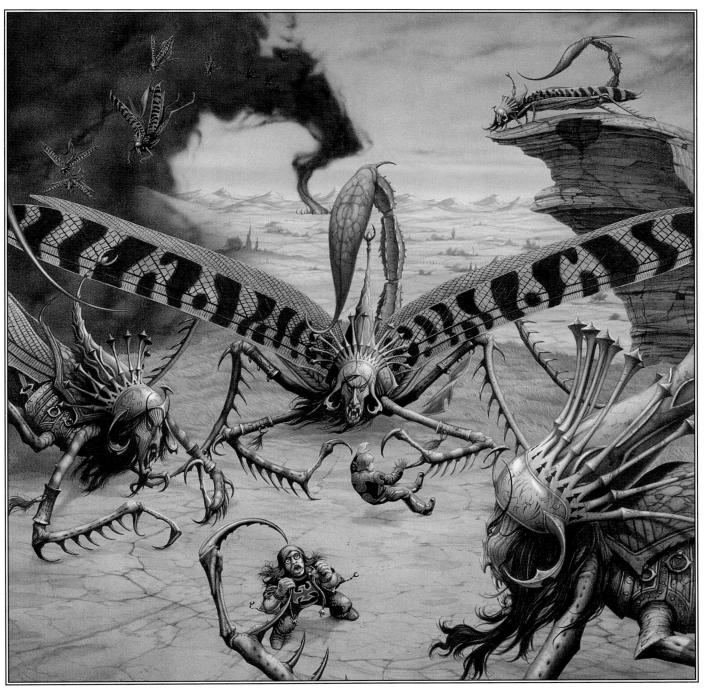

OUT OF THE PIT 1991
Inks. 41 x 41cm
*'They were told not to harm the grass of the earth or any plant or tree,
but only those people who did not have the seal of God on their
foreheads.'* (Revelation 9:4)

Although musically inclined himself, Matthews accepts the view that over the past few decades, much of it has been a vehicle for negativity and self-destructiveness (which is, in fact, one interpretation he has heard of this picture!). The unfortunate victim's modern dress is to emphasize that St John's visions, at least some of them anyway, apply to current times. A related image was used by the band Seventh Angel for their album *The Torment* (page 52).

THE TWO HUNDRED MILLION 1992
Inks. 41 x 41cm
*'And the four angels who had been kept ready for this very hour and day and month
and year were released to kill a third of mankind. The number of the mounted
troops was two hundred million. I heard their number.'* (Revelation 9:15–16)

Spiritually speaking, behind this army stand four fallen angels marching on
Jerusalem across the Euphrates. A slight liberty was taken in making the warriors
Chinese, but that is where an army this size is most likely to come from. Otherwise
the Revelation description is followed closely, though Rodney is not absolutely sure
there are two hundred million figures in the painting, as he lost count somewhere in
the background.

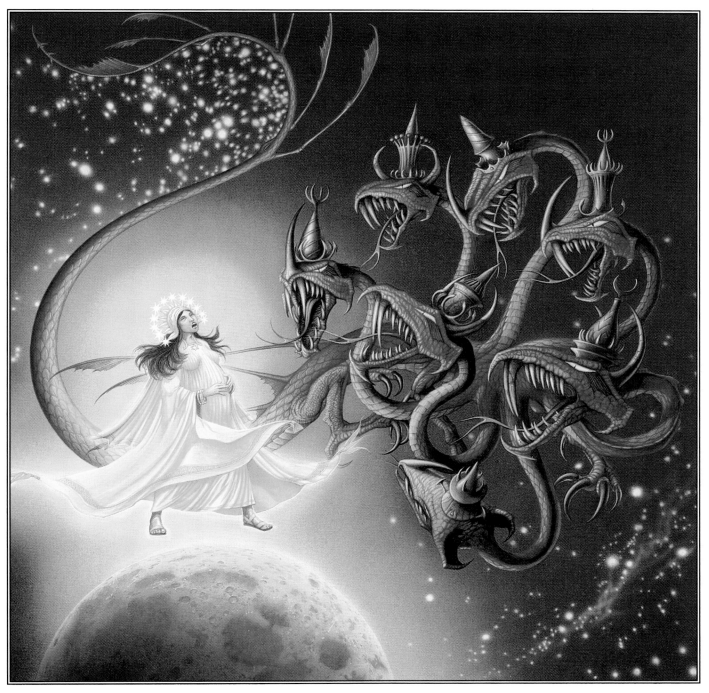

A WOMAN CLOTHED WITH THE SUN 1993
Inks. 41 x 41cm
*'The dragon stood in front of the woman who was about
to give birth, so that he might devour her child the
moment it was born.'* (Revelation 12:4)

The dragon represents Satan, and the stars caught in the hook of its tail, about to
be cast down to earth, stand for the third of all angels who followed Satan into
rebellion. It is believed the woman clothed in the sun is the nation of Israel and the
stars in her crown stand for the twelve tribes. The child mentioned is Jesus, whom
the dragon tried to devour through Herod. It is a vision of past events but many
believe that part of the chapter refers to a future time when Israel takes refuge in
the desert from Satan's emissary, the Antichrist.

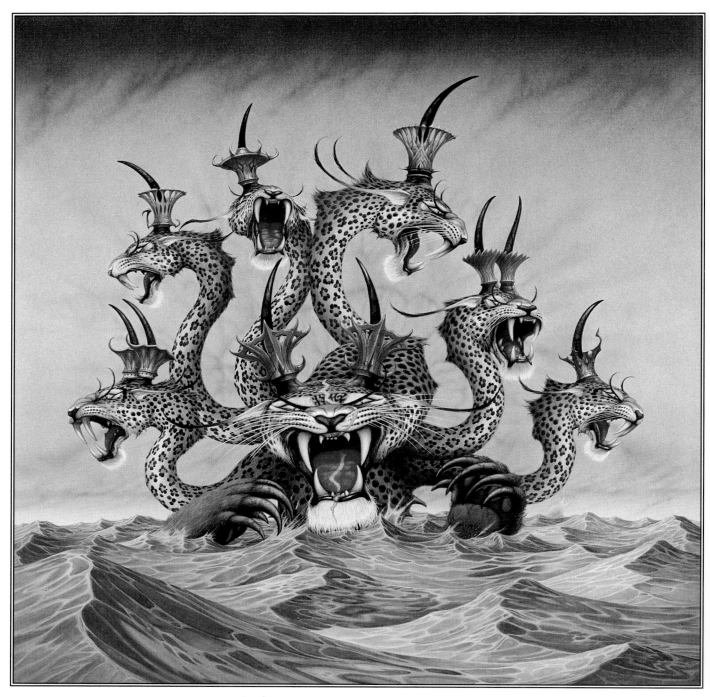

THE BEAST OUT OF THE SEA 1991
Inks. 41 x 41cm
*'The whole world was astonished and followed the beast. Men worshipped
the dragon because he had given authority to the beast, and they also
worshipped the beast and asked, "Who is like the beast? Who can make
war against him?"' (Revelation 13:3–4)*

Symbolically, the sea here is usually interpreted as the population of the world, and
the beast as some earthly vehicle for the Antichrist. Some international body, perhaps
the European Union, is the choice of many interpreters. Much speculation has centred
on the wounded head, which is often identified with Germany or even, these days, with
Russia. Matthews' own feeling is that each head could represent a continent.

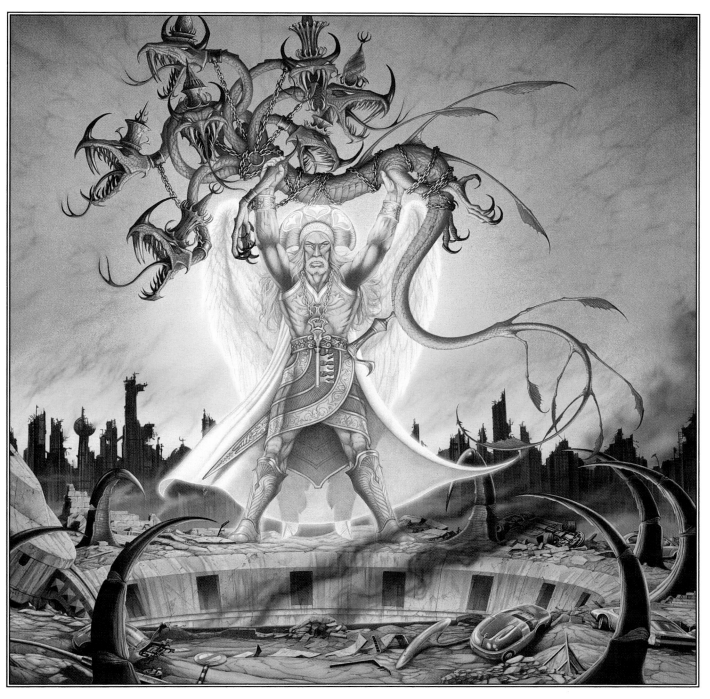

INTO THE ABYSS 1990
Inks. 55 x 73cm
*'He seized the dragon, that ancient serpent, who is the devil, or Satan, and
bound him for a thousand years. He threw him into the Abyss, and locked and
sealed it over him, to keep him from deceiving the nations any more until the
thousand years were ended.'* (Revelation 20:2–3)

The Revelation tells us that after tremendous upheavals and tribulations Christ will
return and his mighty angel will cast Satan into a bottomless pit and seal him there
for a thousand years, during which time peace and justice will prevail on the earth.
Then follows another brief period of turbulence before evil and the old order are
ended forever, death and even hell itself being cast into a lake of fire.

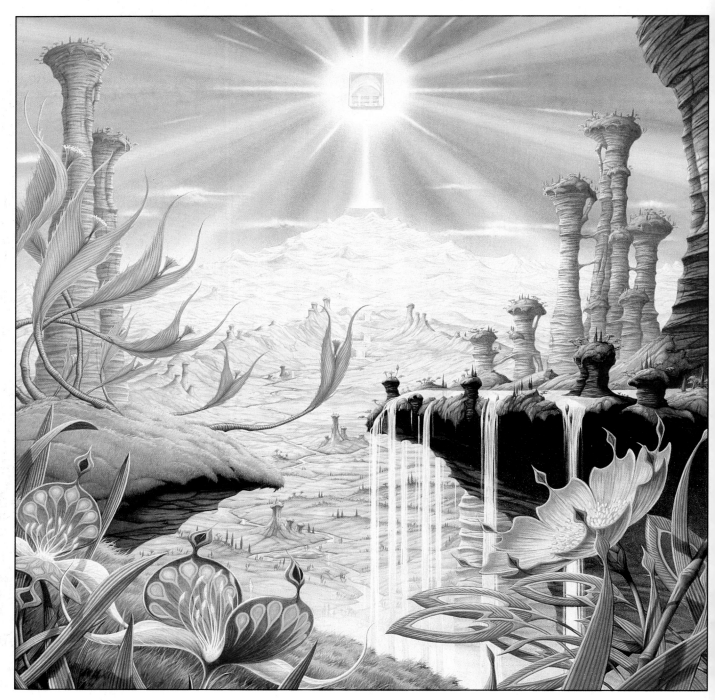

THE NEW JERUSALEM 1993
Inks. 41 x 41cm
'"...They will be his people, and God himself will be with them and be their God. He will wipe every tear from their eyes. There will be no more death or mourning or crying or pain, for the old order of things has passed away." He who was seated on the throne said, "I am making everything new!" Then he said, "Write this down, for these words are trustworthy and true."' (Revelation 21:3–5)

Matthews has been criticized for lack of imagination in his portrayal of the New Jerusalem. He has even suffered the indignity of hearing it compared with a giant flying fridge. However, the text seems to describe the city quite clearly as a glowing crystalline cube. Although he himself is not very happy with it, this is the best he could do. By way of compensation he let his imagination loose on the landscape and vegetation, which in the promised new world are far more beautiful and marvellous than we can know.

SECTION 4 : SCREEN

The urge to create characters that come to life on the screen has been with Rodney Matthews almost as long as he can remember: 'As a child I used to go and watch *Snow White*, *Pinocchio* or *Peter Pan* (one of my special favourites) then rush home and try to draw the characters from memory. Even as a kid I was rarely without a picture on the go. My father encouraged me by drawing Disney characters straight on to the walls of our living room with crayons. Looking back on it, that was a bit strange I suppose, but at the time I just loved it. Later I got into my own kind of art but always the whole Disney enterprise hung in front of me like a mirage. Whilst I enjoy creating straightforward images, I've also always wanted to see them move. With early Disney I love the technique, humour and emotional angle. After seeing *Peter Pan* I really did want to go and live on a desert island. Walt Disney had something special. I read a biography of him recently and almost wept at the end because he's gone, because there is no way of going to see him any more. I see Disney as it used to be.'

Animating his own work has been a long and elusive quest for Matthews, however, with many will-o'-the-wisps that have previously led nowhere; but a welcome development is that all the ideas in this section have been commissioned. They are not just purely speculative ventures on the artist's part and, with the cost of high-class animation tumbling with the development of new technology, a breakthrough has now happened with *Lavender Castle*.

A storyboard for Matthews' 'Nasties' project already includes a hilarious opening sequence, bringing to life the Omigooli Bird, Bog Scrambler and assorted cantankerous goblins familiar to readers of Matthews' earlier books. This revival of 'The Nasties' fulfils two ambitions at once because the project began as long ago as 1977 with an idea for a kind of 'Unnatural History' handbook, a field guide to some of the more obscure creatures inhabiting the British Isles, narrated by a cracked David Attenborough type. Several publishers have been approached over the years with mock-ups of the idea but none could see a 'suitable pigeonhole for it', as the phrase goes. So until recently it was a bitter disappointment for Matthews, though he continued to add to the series whenever he had a spare moment. Then, in 1993, Doug King rang from California to see if Matthews was interested in computer animation, and whether he had any suitable characters available. The possibility of 'The Nasties' was raised and about two years later King bought the temporary rights to the characters in order to do a trial run. For this he also commissioned a number of detailed character designs, which involved drawing three different elevations of each subject to enable a computer to build complete 3-D images of them. Some matte backgrounds were also required, which were both educational and fun to do.

THE GIANT WHEEZEBALL

Page 99 **Figures for computer animation**

'THE NASTIES' Proposed TV series

The revival of 'The Nasties' has led to fresh fieldwork which has uncovered a number of previously unknown creatures, such as the Giant Wheezeball above. As you may have guessed, it is a naturally jet-propelled creature fuelled by a totally indiscriminate appetite. 'The Nasties' tales are not for those who are squeamish about such matters, as is made abundantly clear in the title sequence. Another aspect which adds to Matthews' enjoyment of these characters is the quick, spontaneous painting style they allow.

GOBLIN-EATING TOADSTOOLS

Whether the toadstools above are animal or vegetable is unclear, but on the whole they perform a useful ecological function. As the name suggests, their habit is simply to wait around till some unsuspecting goblin settles down in their shade and then gobble him up. They would probably enjoy other creatures just as much, or even more, but only goblins are dumb enough to keep falling for the trick.

The one safe place in their vicinity is on the top of their heads because their arms cannot reach that high – something important to remember if you ever come across one!

THE ARMOURED SIMPLETON

THE GREEN-FACED FOREST TROLL

THE SPIKED SIDE-SCUTTLER

THE DREADED TUNNEL SPIDER

THE GIANT WART BAT

THE LESSER LEWDMOUTH ON GREATER DUNG-FLY

Company Logo 1996

The logo above was chosen from five pencil sketches produced for a Liverpool-based computer game design company. It was derived from their previous Pumpkin logo for use on notepaper, publicity material, games boxes and CDs, the first of which was the top-selling F1 game for Playstation and PC.

It was also a pleasure to work with Travellers Tales, a small independent company that designs computer games for the major distributors. They even bought the original artwork that Matthews created. There are two aspects to the company's products, 'olde worlde' and futuristic, which Matthews aimed to capture in the pairs of contrasting logos shown on the following pages.

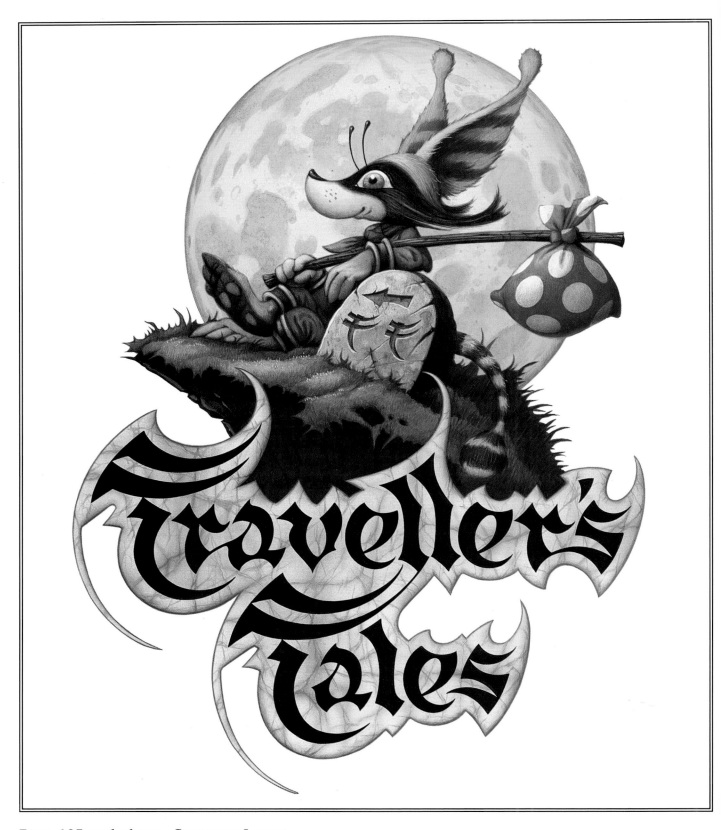

Page 105 and above **Company Logos**

It all started at a signing session at the Crossfire music festival in Liverpool. Matthews signed some posters for a man named Jon, who mentioned he was involved in computer games and would like to work with Rodney in the future. Six months later, Jon's partner in Travellers Tales rang to commission the logos. On delivering the designs, Matthews was introduced to a man called Steve who was

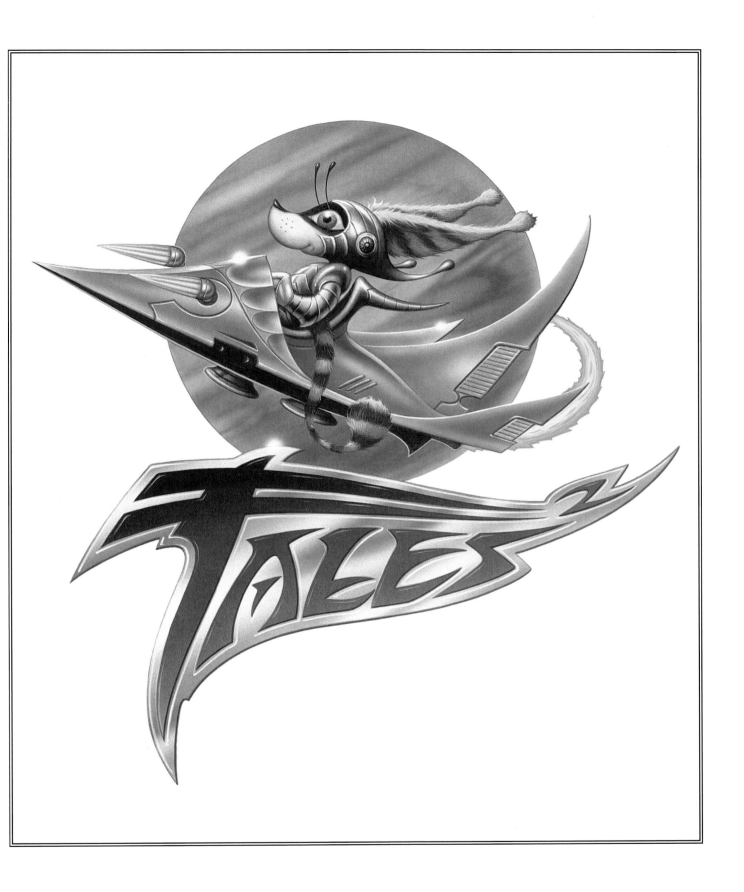

visiting Travellers Tales' offices at the same time. He turned out to be a senior producer with one of the biggest games companies in the world, and a great Matthews fan. After a pint in the pub across the road, with almost alarming casualness, Matthews found himself commissioned to design the characters and scenario of a computer game, the results of which are on the following pages.

Page 106 & above **Sketches for a computer game**

Only three sketches of this project for Travellers[2] are shown here because in the fiercely competitive world of computer games it is best to give as little as possible away until your brainchild is in the shops.

In the past, Matthews has had serious doubts about computer games – partly because some venture recklessly into occult territory and, from an artist's point of view, the graphic quality was dreadful. However, there have now been enormous technical advances and any moral qualms were removed here by having Matthews himself devise the scenario. His attitude has softened anyway through contact with his son Yendor's games, and he was enormously impressed by the potential of computer animation demonstrated in *Jurassic Park*.

In practice, Matthews knows very little about computers. He can just about find his way around his own CD-ROM, but that's about it so far. However, as long as there is someone else around to punch the keys, he is starting to feel quite at home with the medium. For this game, the technical possibilities of both the visuals and the game itself were explained by experts, which is essential in such a rapidly evolving field. Within these boundaries he was given pretty much a free hand and was able to work in many of his pet themes and motifs, which will be familiar to those who know his work.

The experience gained from this animation also seems likely to prove useful in the *Lavender Castle* project, which we will consider next.

SHORT FRED LEDD

LAVENDER CASTLE

The *Lavender Castle* project has been ten years from conception to commencement. Its germ was a whimsical lyric Matthews wrote for his band in the early 1970s. In the late 1980s, the idea blossomed with interest from film producer Gerry Anderson (of *Space Precinct, Thunderbirds* et al. fame). A number of characters and storylines were fleshed out with the aim of producing a classily animated TV series, but then a series of complications, mainly connected with raising finance, put the project in the doldrums until 1996. Things then took a turn for the better, so that at the time of writing the project is well into pre-production, thanks to Carrington Productions International.

Lavender Castle is a comic space-action adventure series aimed at viewers of nine and above. Initially there will be a run of twenty-six ten-minute episodes created in both stop-motion and computer animation with computer-generated enhancement. Apart from Gerry Anderson, other creative participants include the children's novelist Pauline Fisk, composer Crispin Merrell and computer animator Steve Weston. Other characters and early drawings from *Lavender Castle* are also featured in Matthews' previous anthology *Last Ship Home.*

THE PARADOX

COLONEL CLUMP

109

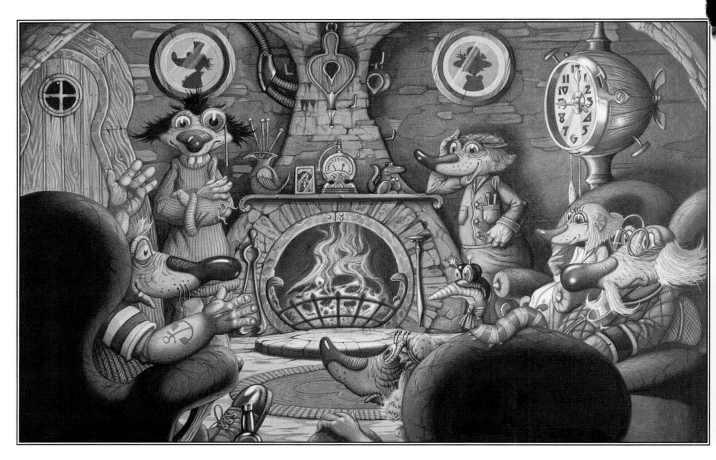

'THE WIGGLEYS'

As well as the other ventures covered in this section, Matthews has formed his own company, Yendor's Images, to explore the possibilities of animation, beginning with 'The Wiggleys'. These characters were originally the brainchildren of his partner in the company, Rob Copeland.

Before they met, Copeland had already gone to the lengths of making a pilot episode of 'The Wiggleys' using clay animation, for drumming up interest from TV companies. The script and concept were well received, but it was generally felt that the look of the characters and their environment was not original enough, so keeping the same script, Matthews was brought in to redesign them.

The initial results can be seen above and opposite. In the course of the work it emerged that Matthews and Copeland had so much in common, including a commitment to Christianity, that the further idea arose of going into partnership. This is probably the most speculative of Matthews' current animation ventures, but that in itself has its own appeal.

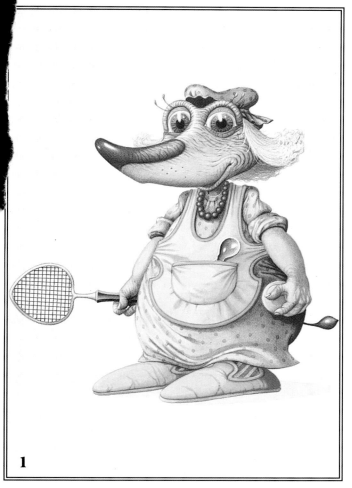

1

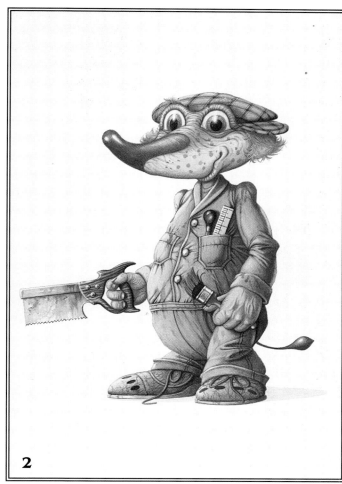

2

1. GRANDMA WIGGLEY
2. NOAH WIGGLEY
3. CALVIN WIGGLEY
4. KAFKA THE BOOKWORM

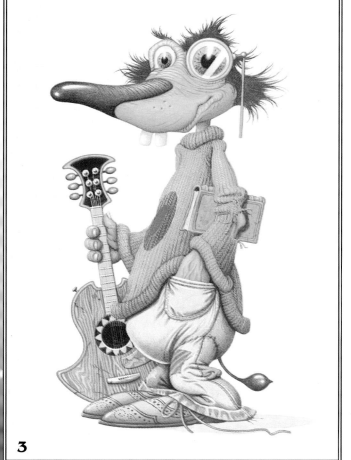

3

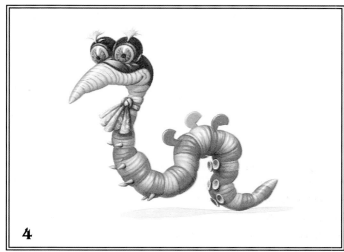

4

Thanks to:
Karin, Yendor and Elin
to Nigel Suckling for the text
Jim Price and Colour Studios for the transparencies
Tino Troy for the loan of a long lost record cover.

Thanks also to the following for their help and/or encouragement
during the period 1989 – 1995:
Tim Jones and Martin Bridges, Dave Williams, Ken Eaves, George Russell,
Rick Wakeman, Bob Moon, Rudi Dobson, Paul Birch, Tony Clarkin,
Rodd & Marco, John Ray, Carlton Watts, Rob Copeland,
Gerry and Mary Anderson, Pauline Fisk and Chris Beetles.

'At that time the sign of the Son of Man will appear in the sky, and all the nations of the earth will mourn. They will see the Son of Man coming on the clouds of the sky, with power and great glory.' (Matthew 24:30)